Carolina

PHOTOGRAPHS FROM THE FIRST STATE UNIVERSITY

Edited by Erica Eisdorfer *Foreword by* Doris Betts

Published in Association with UNC STUDENT STORES University of North Carolina at Chapel Hill

by THE UNIVERSITY OF NORTH CAROLINA PRESS Chapel Hill

Carolina

© 2006 The University of North Carolina Press
Set in Scala types
Printed and bound in the UK by Butler and Tanner, Frome

The paper in this book meets the guidelines for permanence and durability of the Committee on Production Guidelines for Book Longevity of the Council on Library Resources.

Library of Congress Cataloging-in-Publication Data
Carolina: photographs from the first state university / edited by Erica Eisdorfer; foreword by Doris Betts.
 p. cm.
ISBN-13 978-0-8078-3035-2 (cloth: alk. paper)
ISBN-10 0-8078-3035-6 (cloth: alk. paper)
 1. University of North Carolina at Chapel Hill—Pictorial works.
I. Eisdorfer, Erica.
LD3944.5.C37 2006
378.756'565—dc22 2005034942

Halftitles and title page: The Old Well. Photographs by Tim Buchman.

10 09 08 07 06 5 4 3 2 1

FOREWORD

The cliché that one picture is worth a thousand words was never intended to compare the average vacation snapshot against the even shorter 23rd Psalm or Hamlet's soliloquy. Yet the saying does acknowledge that one really good picture can do what Eudora Welty—herself a photographer—said: it can "stop a moment from running away."

The camera can freeze time so effectively that Grandma will always stay unwrinkled, the child be prevented from adolescence, and a backyard rose keep blooming red through untold winters. Pictures seem to exist in present tense.

For me, as a child, the camera also predicted a future tense toward UNC-Chapel Hill. During the 1930s my father (forever preserved black-haired and young in the family album) spent a weekend in Chapel Hill with a friend who was a student there. Dad was just off a sharecropper's farm and just recently out of the Navy, and a college education had never been a prospect for him or his siblings. He never got over his brief but admiring taste of academia, and he brought home a small wooden souvenir box of campus photographs, each the size of a calling card. Nights after his shift as a weaver in the mill, he would deal these out on the kitchen oilcloth so I could see and marvel for myself how many rooms were required to teach chemistry, what a tall building was needed just so young men could understand poems.

A university, he would say with awe, was not a bit like the textile mill where he worked for low wages. No boss could see or test or measure whatever product a university was turning out; decades would slide by before anyone could tell whether brains had been expanded or lives deepened because of spending a few years at Carolina. Professors there, he'd been told, often read the same book twice and expected students to do the same. They did these bookish activities all day long, eight hours plus overtime, plus some equivalent to piecework. And he said that, as far as he could tell, both Albert Schweitzer and Adolf Hitler had been smart, had read many books themselves in buildings that looked like these, even if one had devoted his life to good, the other to evil.

Of course those shrunken sepia photographs plus his wistful fascination kindled in me an advance homesickness for a Chapel Hill I had not seen. But his memento pictures were not like the ones in the pages that follow. My souvenirs showed brick and stone and mortar. By contrast, in this collection the mystery that so intrigued my father is made manifest on almost every page, as young men and women are seen going in and out of these buildings, climbing the stairs, throwing the ball, reading the library book.

In these pictures, the university has become populated, and though there's still no bottom line to total the value of its graduates, no tangible product like fabric spun from thread, these young faces bring to life Carolina's ongoing purposes. A host of sons, now daughters as well, a growing student body interracial and international—

these young people make mere classrooms and office buildings shine with their future promise. Their youthful, lively faces would be enough to make my father dream of more Schweitzers.

If old, emptier pictures drew me long ago to Chapel Hill, these scenes will call back past experiences of alumni and visitors. Frank Deford described one woman this way: "She glances at the photo and the pilot light of memory flickers in her eyes." Expect such flickers as you turn these vivid pages. Until now, no such picture book has existed to show Carolina as it is, with the perspective of shadows from the past and occasional lighted glimpses of what might come.

I wish I could show my father every fragile but durable face in these moments the camera has stopped from running away. Many photographers have helped us to see Carolina, not just to look at it. Here we see again our children, our neighbors' children, our grandchildren, until (since memory is a telephoto lens that magnifies) at last we may even glimpse our own remembered faces as they swim youthfully back from the days when we were in this special place, at a very special time.

Doris Betts

PREFACE

In my twenty-five years at the Bull's Head Bookshop in Chapel Hill, legions of people have asked for a book like the one you're holding in your hands. Parents of incoming students ask so that, when they go back home, they can more easily envision their son or daughter at work and play. Students ask so that they can present their parents with a tangible thank-you for sending them to this lovely place. Nostalgic alumni, here on autumn football weekends, ask for a book like this one. Members of the faculty ask so that, when they travel abroad, they can present their hosts with a visual image of the university that sent them. Everyone asks at graduation.

We who have been touched by the University of North Carolina at Chapel Hill are proud of the fact that it is the oldest public university in the country, a university by the people and for the people. We admire its lovely, wooded campus. We esteem its landmarks, such as the Old Well, Wilson Library, and the Bell Tower. We feel that the campus is enriched by such quietly beautiful places as Forest Theatre, Person Hall, and the Arboretum. Walking amidst UNC's engaged student body and superior faculty and staff, we fully understand the university's commitment to diversity, free speech, and the eye-opening wonder of an excellent liberal education. With this book, I have endeavored to select, from among thousands of pictures of the university, those photographs that best reflect the place we love.

All things on campus move toward commencement, and that has been the mission here. From crisp autumn afternoons spent in the library, to thrilling winter evenings in the Dean Dome, to the amazing grace of a Chapel Hill spring morning, and finally to graduation day, the four years of college are presented here, compact, in living color. The pictures prove it: Chapel Hill truly is the southern part of heaven.

Thanks go first and foremost to the dozens of photographers whose work you see in this book. There were hundreds of other photographs I would have liked to include, but there wasn't room between the covers. Thanks also go to Keith Longiotti in UNC's Photographic Archives, to John Jones at the UNC Student Stores, to Christina Bormann at the Yackety-Yack, and especially to Rosemary Sears, who told me many wonderful stories on which some of the captions are based.

I would also like to thank the staff of the Bull's Head Bookshop, especially Frank Bellamy and George Morgan, for their wisdom and patience. Finally, thanks to the University of North Carolina Press, especially Ron Maner, managing editor, and Mark Simpson-Vos, editor and mentor.

Erica Eisdorfer

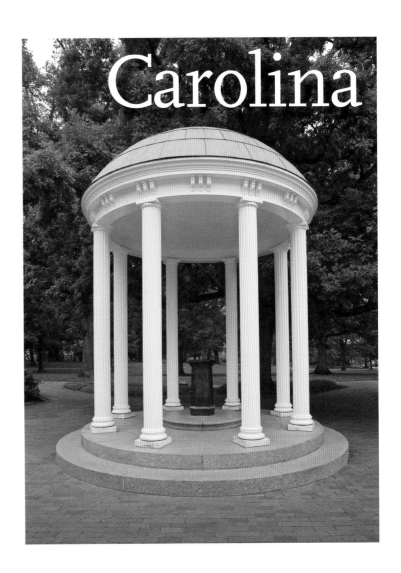

Carolina

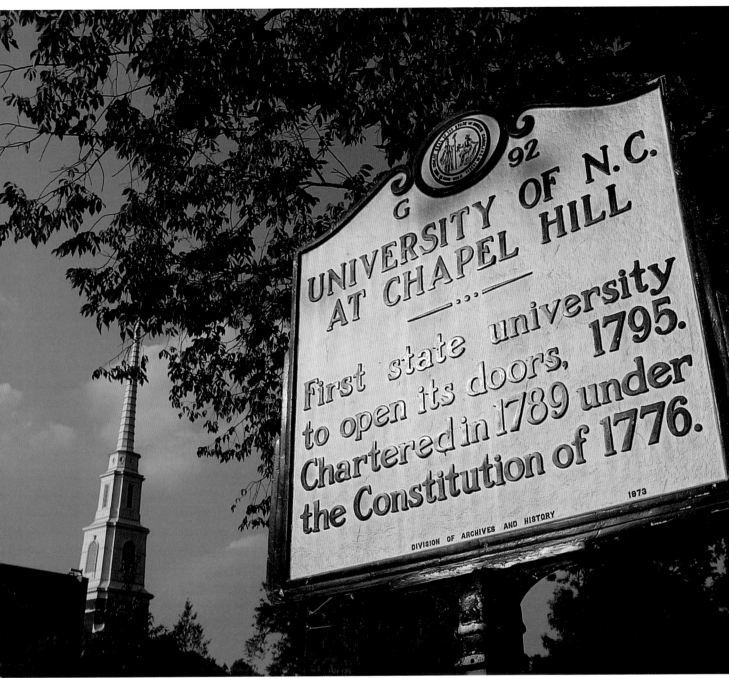

"In Chapel Hill among friendly folk, this old university, the first state university to open its doors, stands on a hill set in the midst of beautiful forests under the skies that give their color and their charm to the life of the youth gathered here. . . .
There is music in the air of this place." —Frank Porter Graham.
Photograph by Josh Greer.

The first trustees of the University of North Carolina, in looking for a site, settled on a tract in Orange County that had the virtues of a crossroads, elevation, clear springs, a central location within the state, and best of all, generous citizens who offered to donate 1,290 acres and £768 to the effort to establish the new seat of learning.

Courtesy of the North Carolina Collection, University of North Carolina at Chapel Hill Library.

S I R,

AT a Meeting of the Truftees of the Univerfity of North Carolina the 25th of November; 1790, It was Refolved, That this Board do meet on the third Monday in July next, at the Town of Hillfborough, in order to fix on the place where the Buildings of the Univerfity fhall be erected, and to do and perform fuch other acts and things as appertain to, and may tend to forward and promote that Inftitution.

Which Refolution I was directed to inform you of and requeft your attendance accordingly.

I have the honor to be,
With great refpect,
S I R,
Your moft humble Servant,

Rockingham County, April 1, 1791.

James Taylor Jun

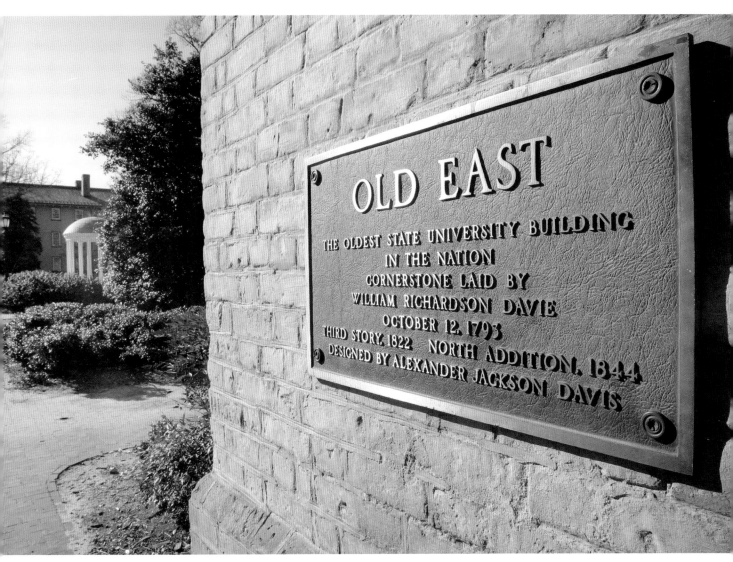

At the university's opening in 1795, East Building housed students and professors, classrooms, and the dining hall. Refurbished for the university's bicentennial, Old East, with its lovely setting and large rooms, today offers some of the campus's most coveted student residences.

Photograph by Justin Smith.

Faculty members process from Memorial Hall to South Building on October 12 — University Day — the anniversary of the laying of the cornerstone of Old East.
Photograph by Justin Smith.

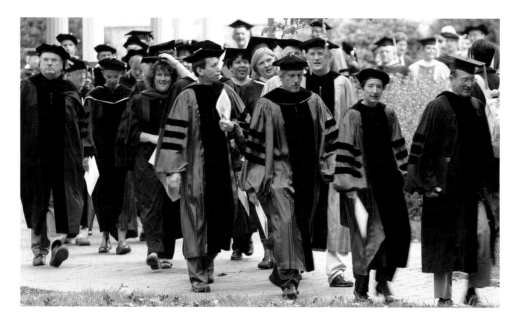

The sidewalks of Polk Place serve as Main Street on a typical campus day.
Photograph by Justin Smith.

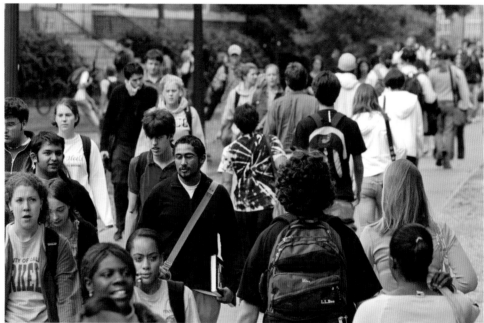

Louis Round Wilson Library served as the central campus library from 1929 to 1984 and now houses special collections. Its quintessential dignity and amassed knowledge draw visitors from around the world. Photograph by Justin Smith.

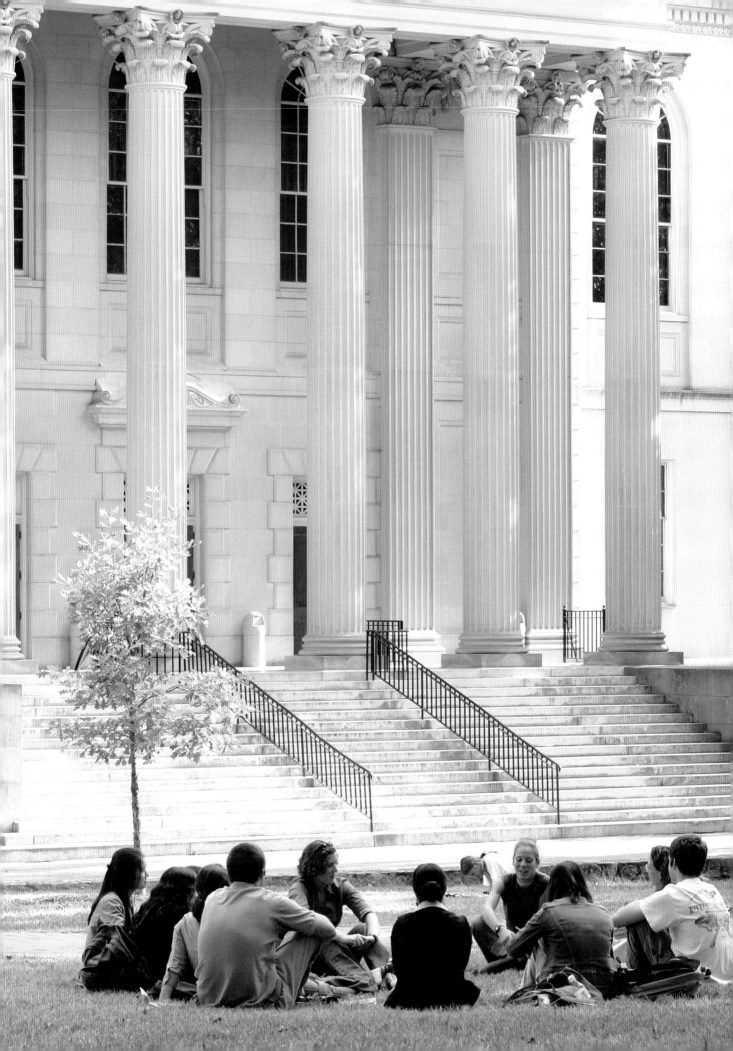

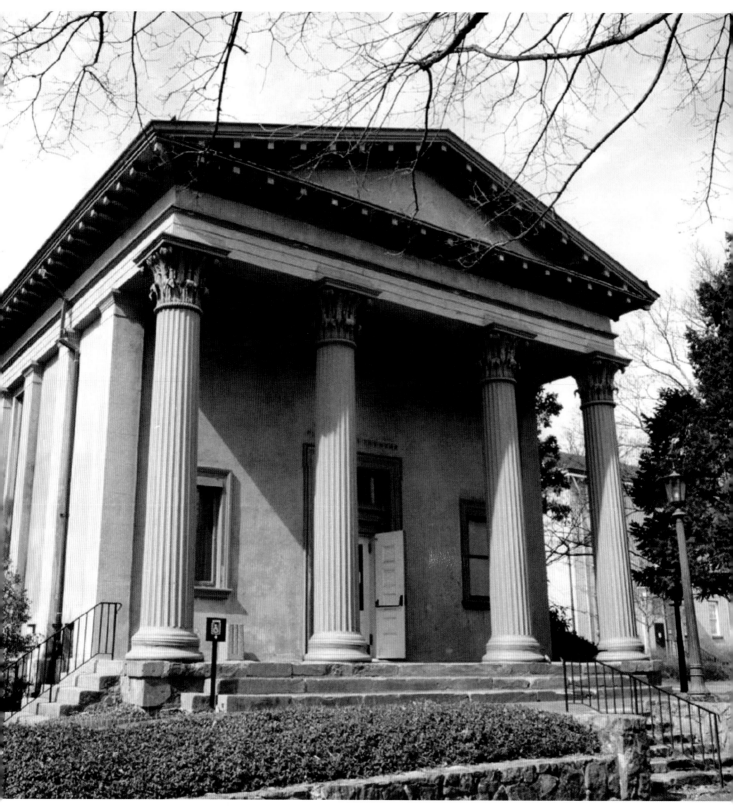

The building once known as Smith Hall, now historic Playmakers Theatre, was the site of the university library from 1851 to 1870, with a two-year hiatus during the Civil War, when Federal soldiers used it as a horse stable. In 1925 it was renovated for use by the Carolina Playmakers and currently hosts all manner of productions. *Photograph by Dan Sears.*

The icon turned metaphor: indeed, the university does shed light.
Photograph by Dan Sears.

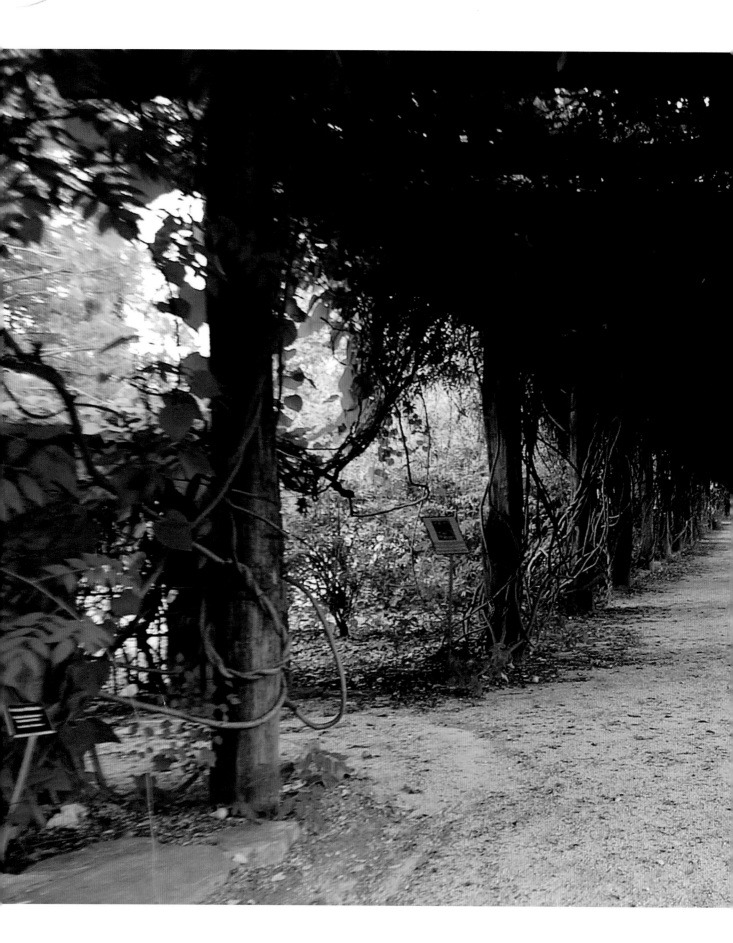

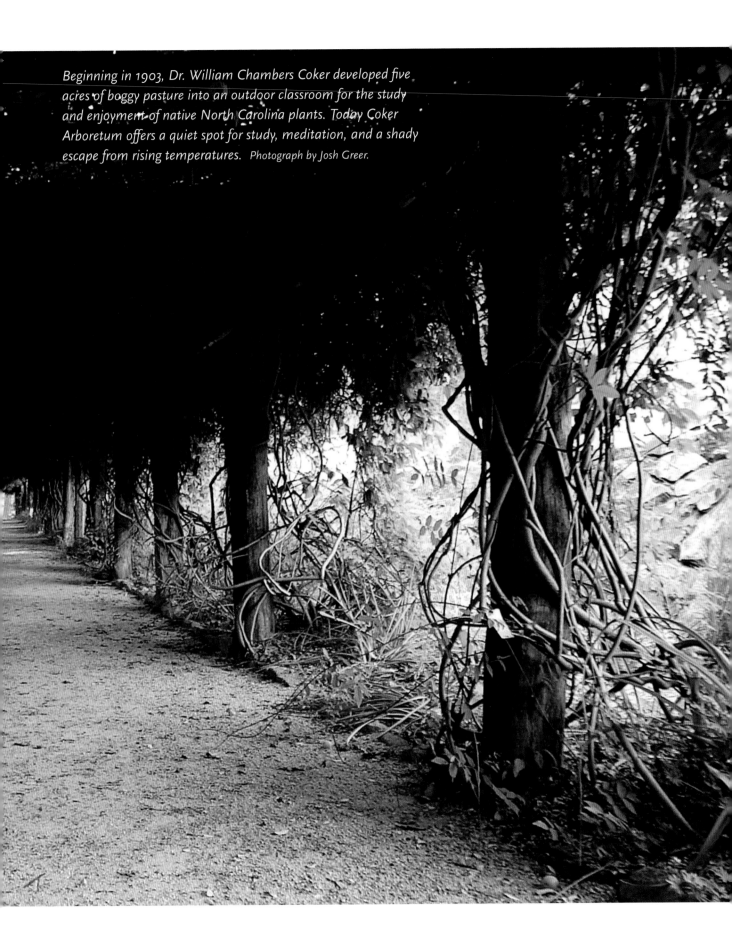

Beginning in 1903, Dr. William Chambers Coker developed five acres of boggy pasture into an outdoor classroom for the study and enjoyment of native North Carolina plants. Today Coker Arboretum offers a quiet spot for study, meditation, and a shady escape from rising temperatures. *Photograph by Josh Greer.*

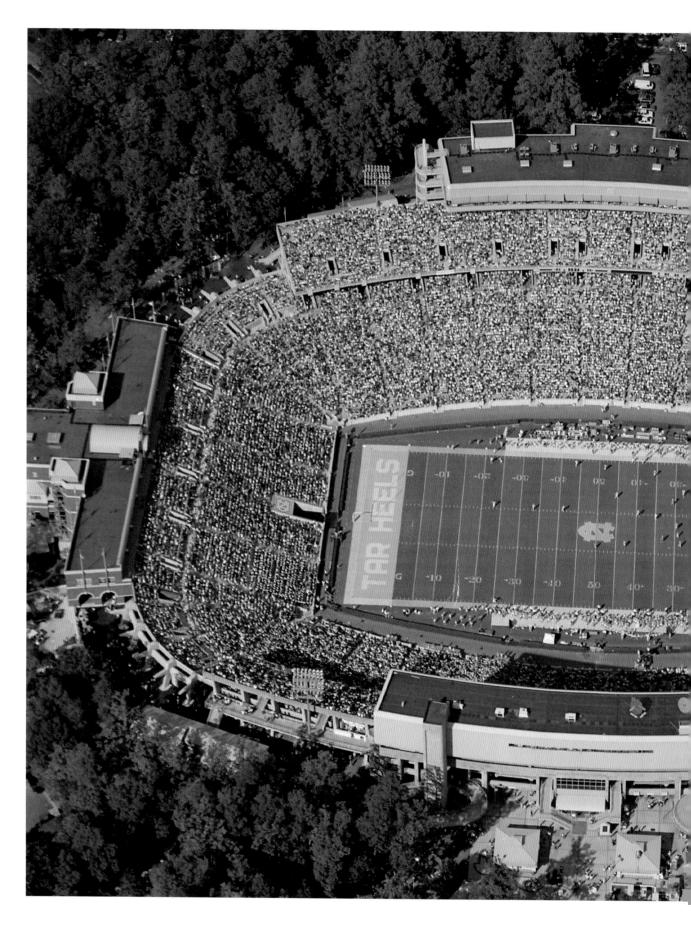

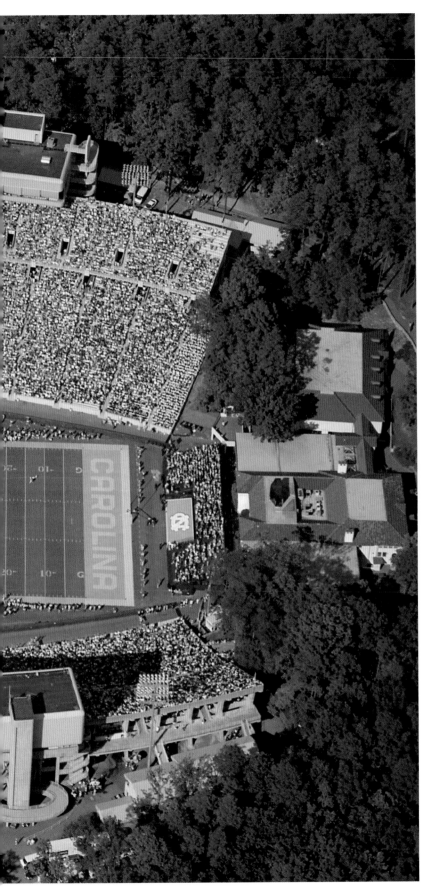

Surrounded by tall pines in the heart of campus, Kenan Stadium, which seats more than 60,000, has been called one of the five most beautiful settings for a college football game. The enclosed west end of the stadium also features the state-of-the-art Kenan Football Center, where the Hall of Honor commemorates the exploits of past Tar Heel greats.

Photograph by Dan Sears.

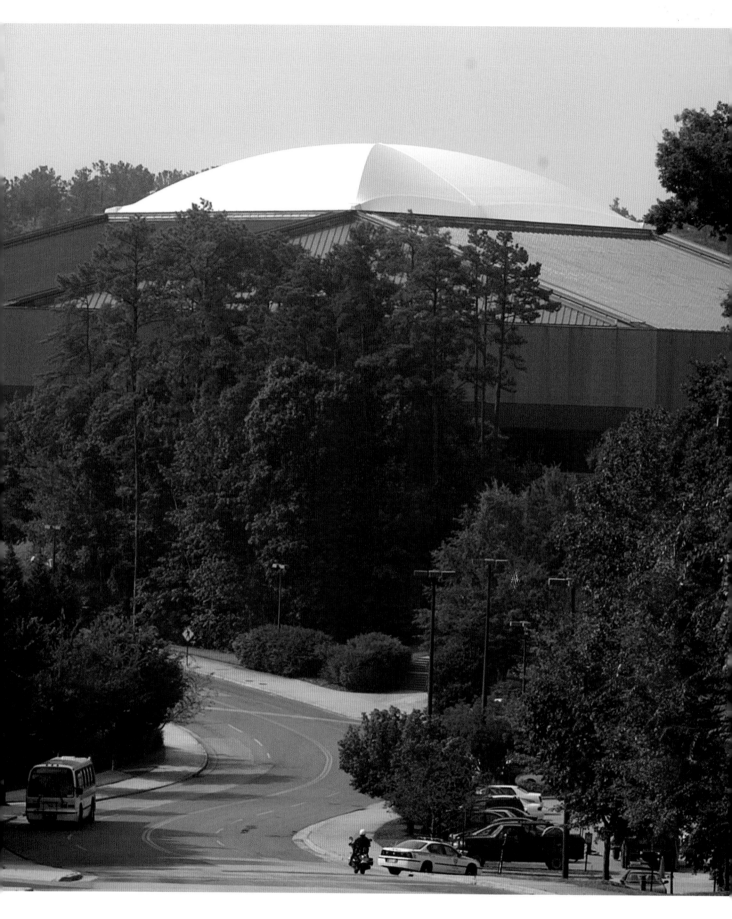

An impromptu volleyball game on North Campus.
Photograph by Josh Greer.

Officially, it's the Dean E. Smith Student Activities Center.
Affectionate fans just say "the Dean Dome."
Photograph by Jeffrey Camarati.

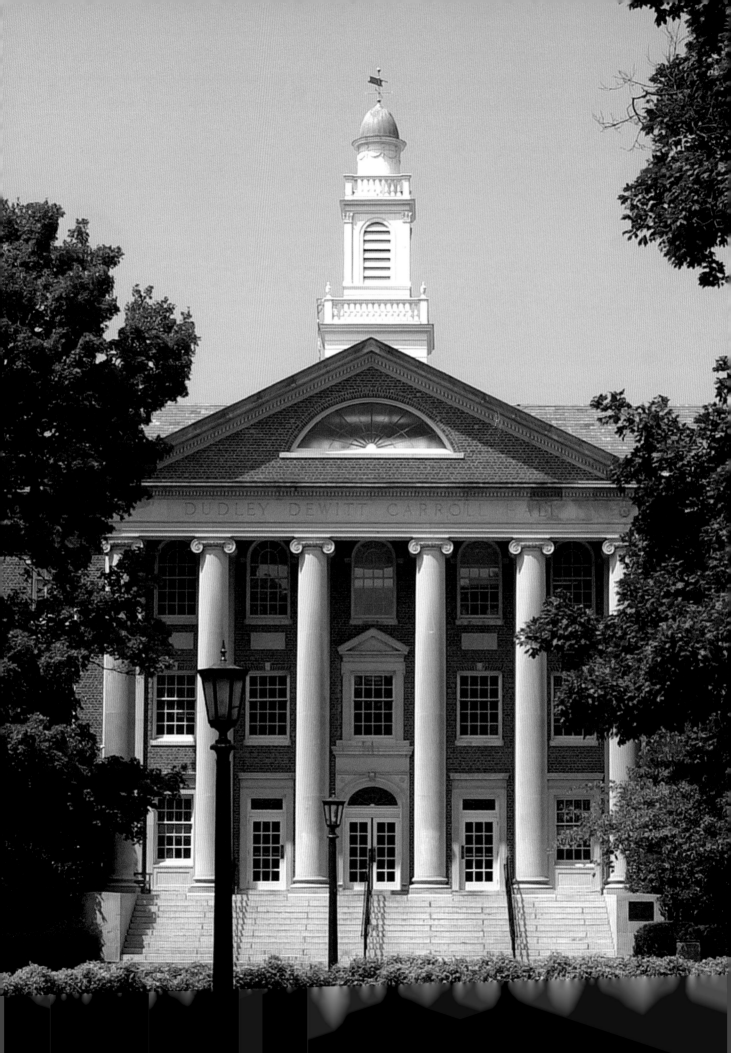

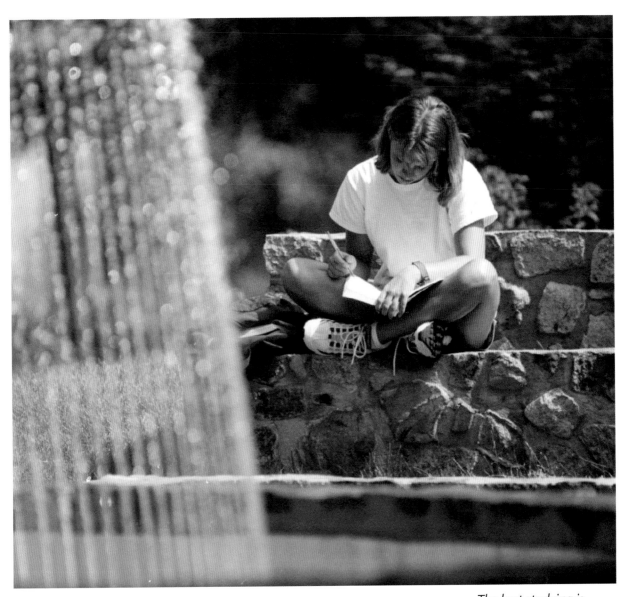

*The best studying is
done as near to the fount
of knowledge as possible.*
Photograph by Dan Sears.

*"We learned, we absorbed . . . that solid tradition, those hopes of
this university born of the beginnings of a new nation, values this
great university continues to nourish—freedom and liberty and
tolerance. . . and the personal courage to stand for those hopes
and truths." —Terry Sanford.* Photograph by Dan Sears.

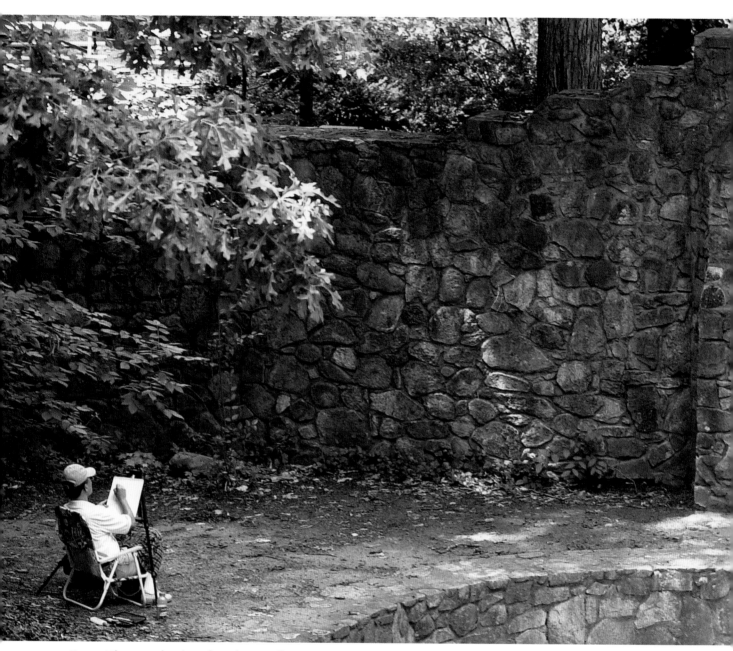

*Forest Theatre, the site of outdoor performances
since 1916, opened with one commemorating the
tercentenary of Shakespeare's death.*
Photograph by Dan Sears.

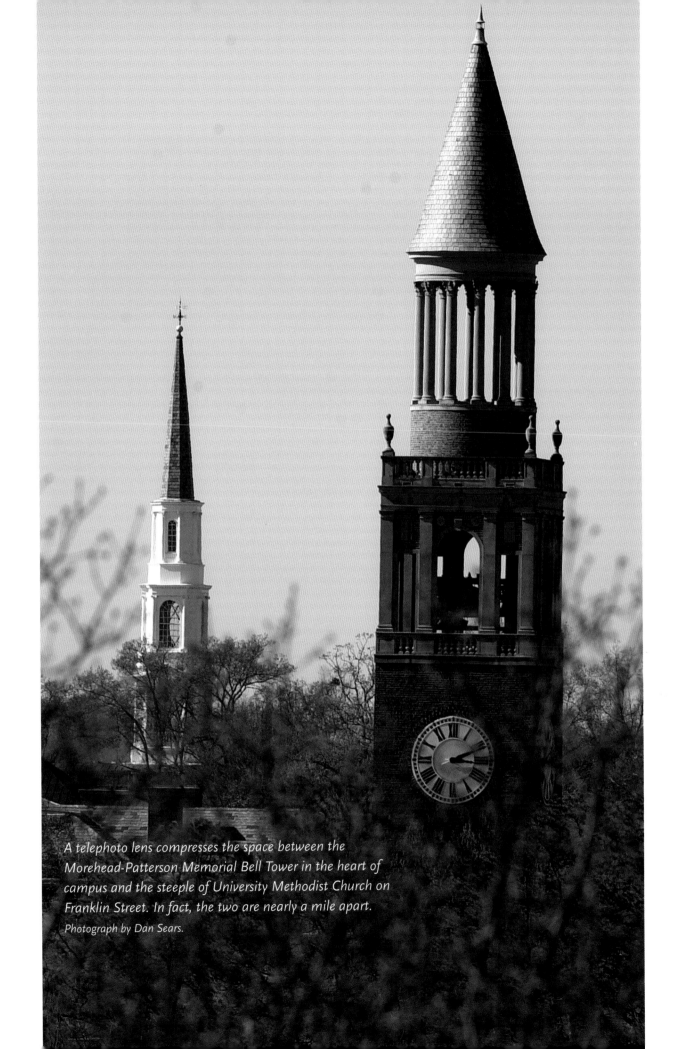

A telephoto lens compresses the space between the
Morehead-Patterson Memorial Bell Tower in the heart of
campus and the steeple of University Methodist Church on
Franklin Street. In fact, the two are nearly a mile apart.
Photograph by Dan Sears.

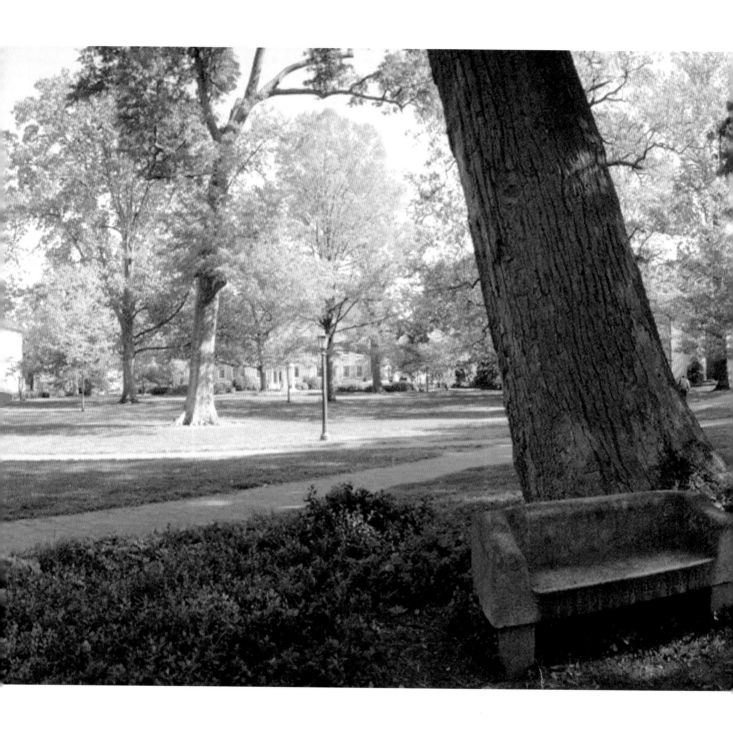

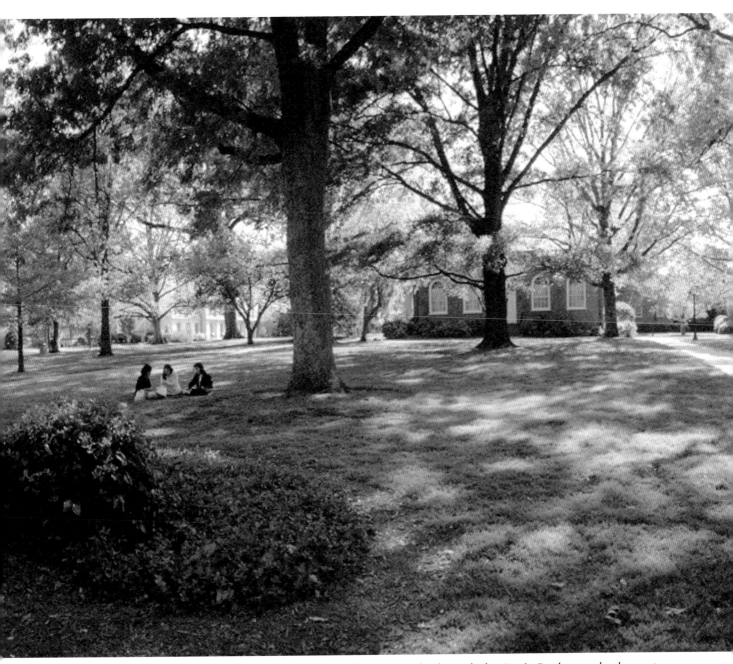

According to popular legend, the Davie Poplar marks the spot where UNC founder William R. Davie decided on Chapel Hill as the site for the university. Another tradition says that students who kiss while sitting on the bench at the base of the tree will one day wed. *Photograph by Dan Sears.*

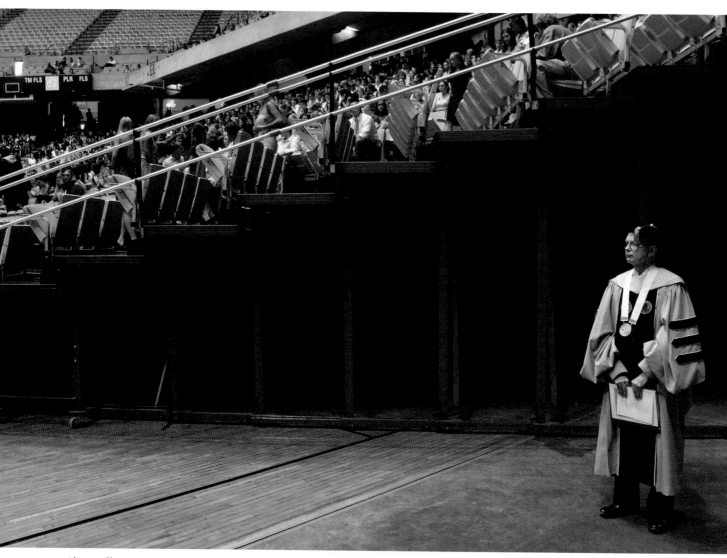

*Chancellor James Moeser waits for his moment: introducing new
Tar Heels to campus at the annual first-year student convocation.*
Photograph by Justin Smith.

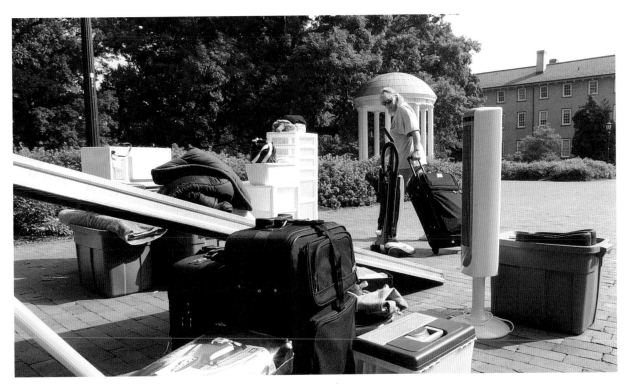

As students move their accumulated belongings into North Campus dorms, parents face the inevitable question: how in the world is all that ever going to fit in there?

Photograph by Dan Sears.

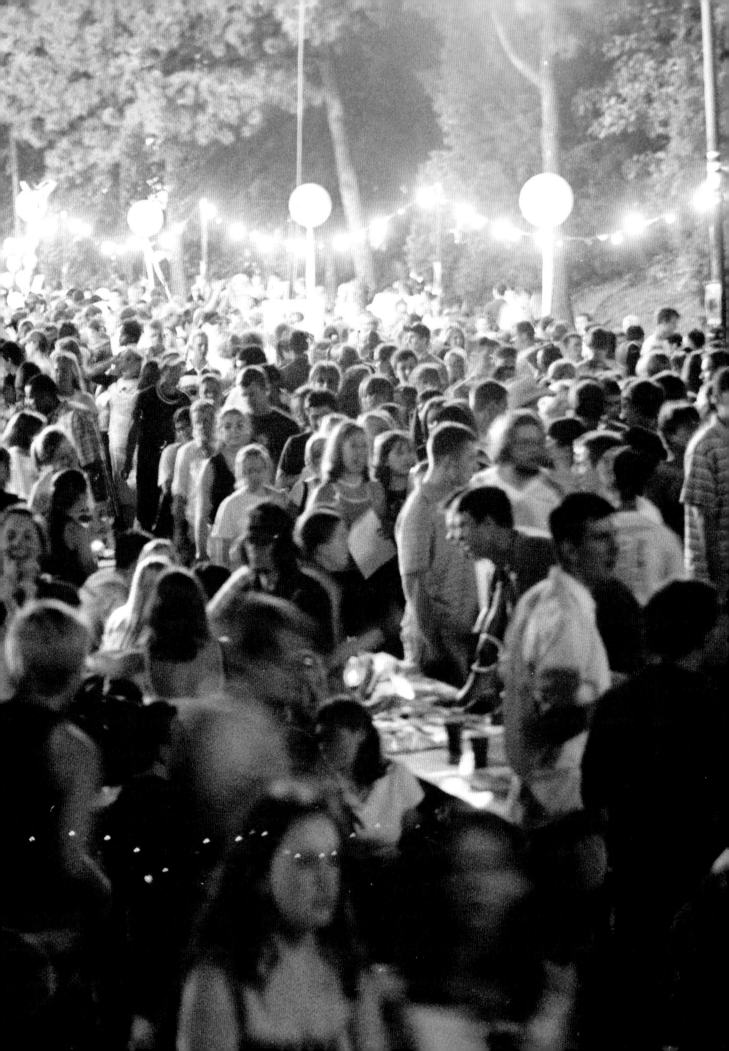

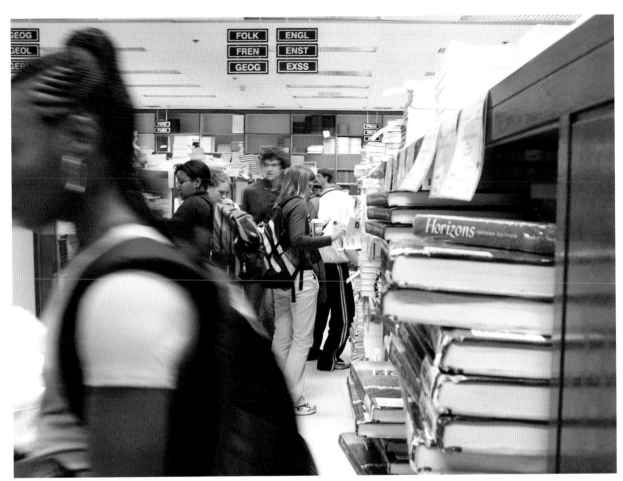

The ritual rush for textbooks.
Photograph by Stacie Smith.

*Fall Fest, with its games, student club representatives,
and food samples, gives Carolina students their first taste
of the many activities they have to look forward to during
their years at UNC.* Photograph by Josh Greer.

*"The Pit," the sunken courtyard
adjacent to the Frank Porter Graham
Student Union, makes a natural stage
for daily events, both serious and not so.*

Photograph by Jonathan Saas.

Students on the sidewalks of Polk Place, near the center of campus.
Photograph by Justin Smith.

A member of the faculty advises her students.
Photograph by Dan Sears.

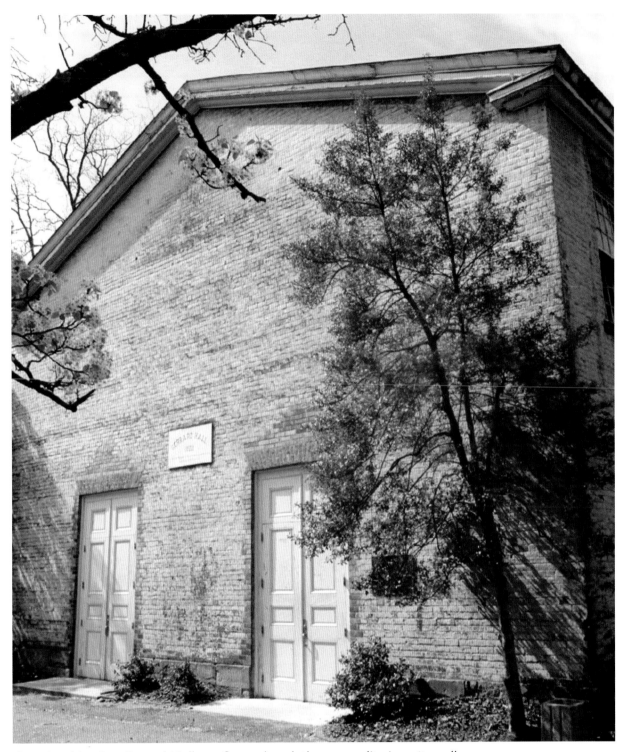

*Completed in 1837, Gerrard Hall was first a chapel, then an auditorium. Its walls
have heard the voices of three U.S. presidents, slave-poet George Moses Horton, and
writer Langston Hughes, among many others, over the years. It is currently a favorite
performance space for Carolina's excellent a cappella singing groups.*

Photograph by Dan Sears.

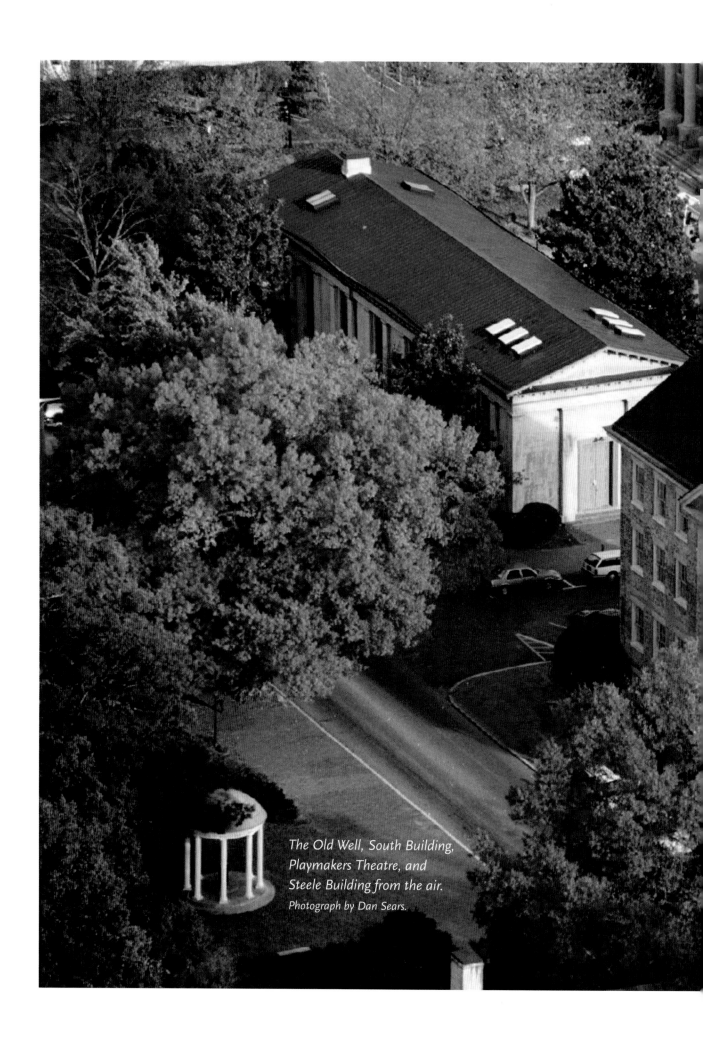

The Old Well, South Building,
Playmakers Theatre, and
Steele Building from the air.
Photograph by Dan Sears.

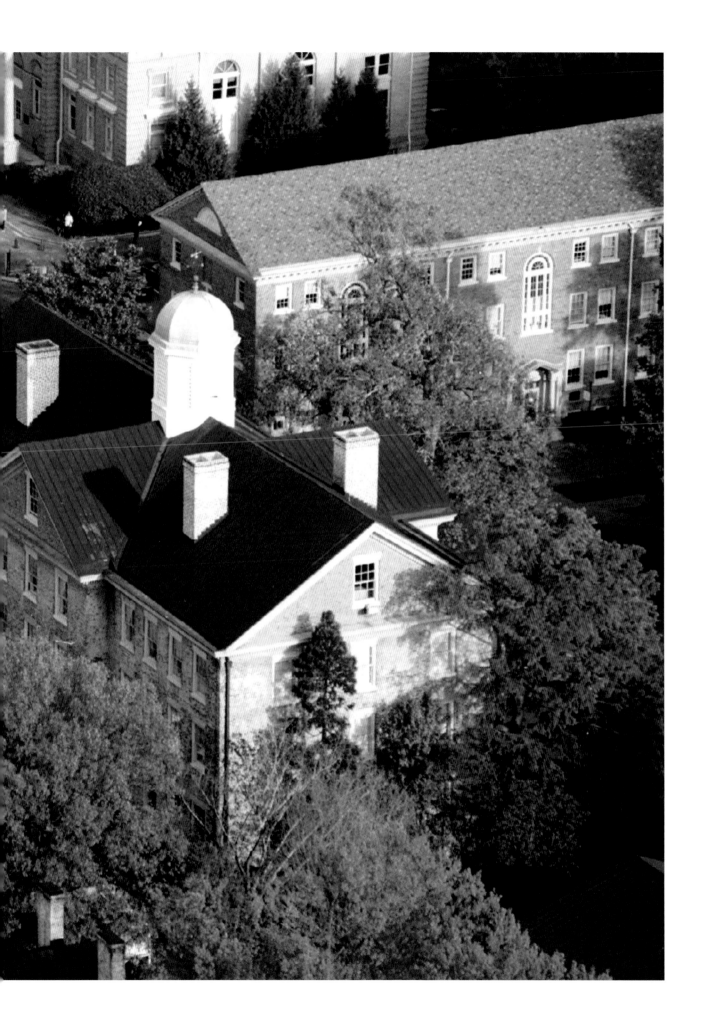

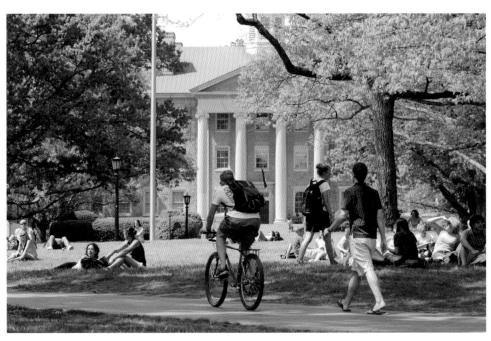

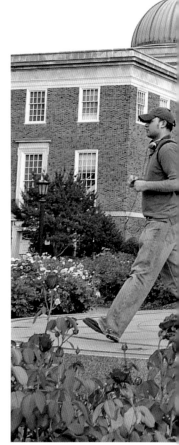

"This university has produced enough excellence to fill a library or lead
a nation. . . . As one who grew up in the South I have long admired
this university for understanding that our best traditions call on us to
offer that light and liberty to all." —President Bill Clinton.

Photograph by Justin Smith.

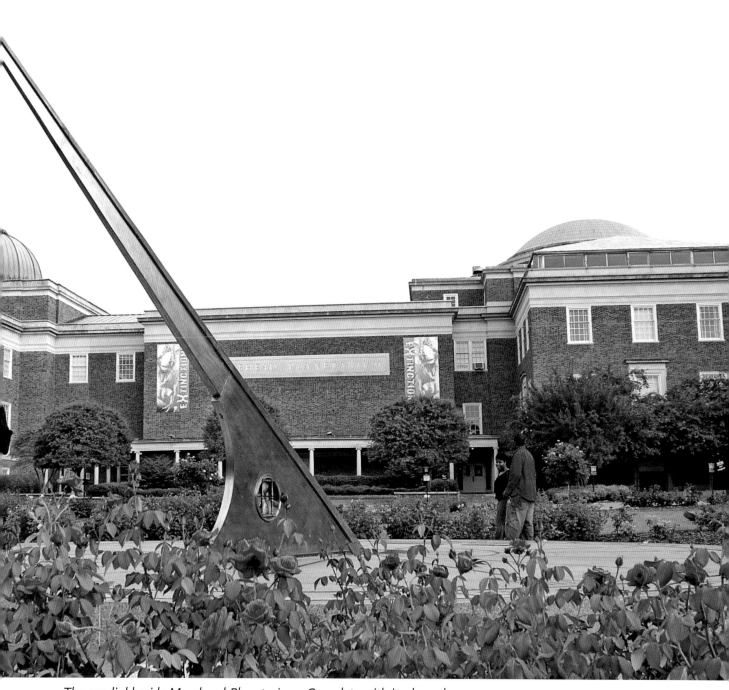

*The sundial beside Morehead Planetarium. Complete with its domed
Star Theater and Zeiss Model VI Star Projector, the planetarium, which
is one of the largest in the United States, serves as a giant classroom for
thousands of students and visitors in love with the above and beyond.*
Photograph by Gary Simpson.

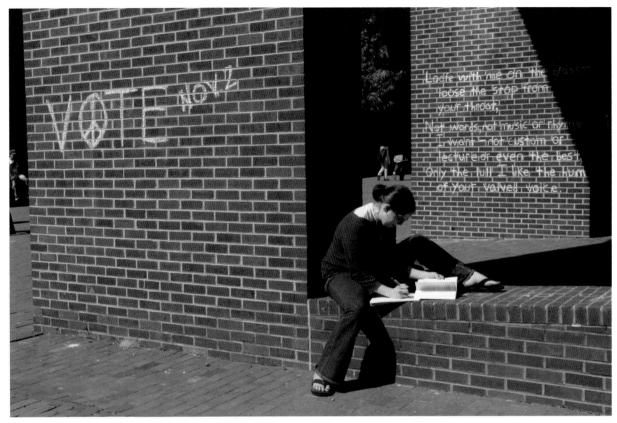

At Carolina, the written word is ubiquitous.
Photograph by Ashley Pitt.

South campus maintenance.
Photograph by Samkit Shah.

Occasionally affording a private moment for a phone call, generally South Campus dorm balconies are the coolest social hot spots.
Photograph by Nancy Donaldson.

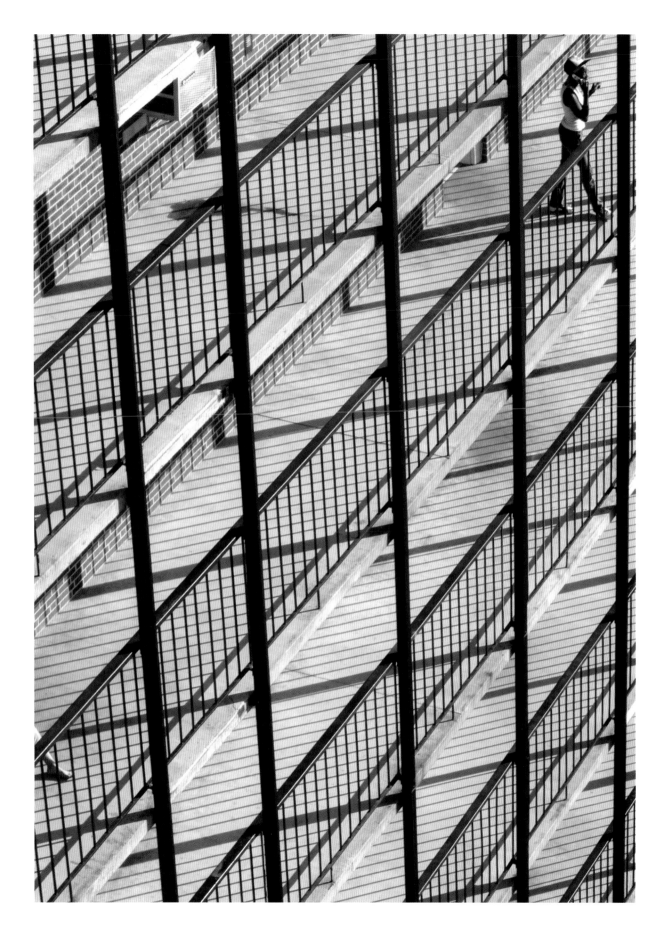

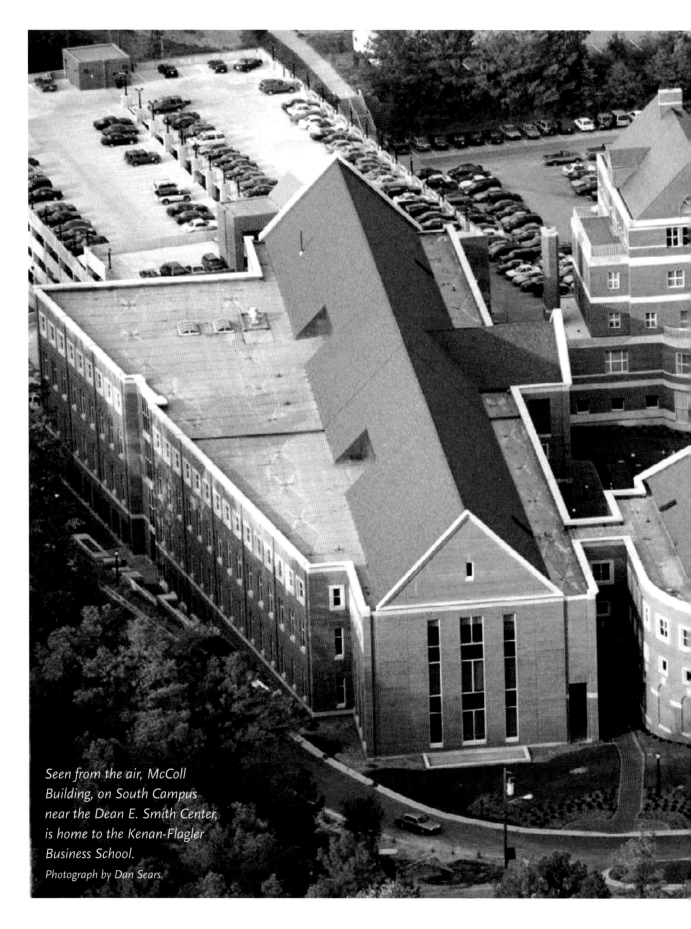

Seen from the air, McColl Building, on South Campus near the Dean E. Smith Center, is home to the Kenan-Flagler Business School.
Photograph by Dan Sears.

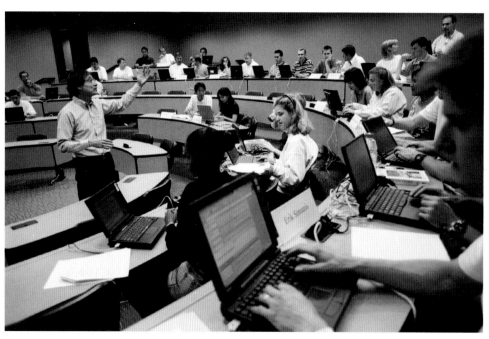

A class in the Kenan-Flagler Business School.

Photograph by Dan Sears.

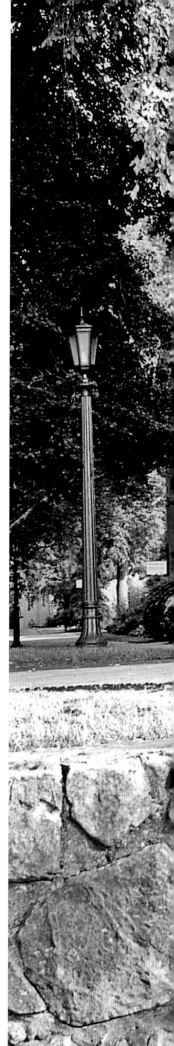

*Battle-Vance-Pettigrew Building,
separated from Franklin Street by
Carolina's beautiful old stone walls—
the original in town/gown distinction.*

Photograph by Gary Simpson.

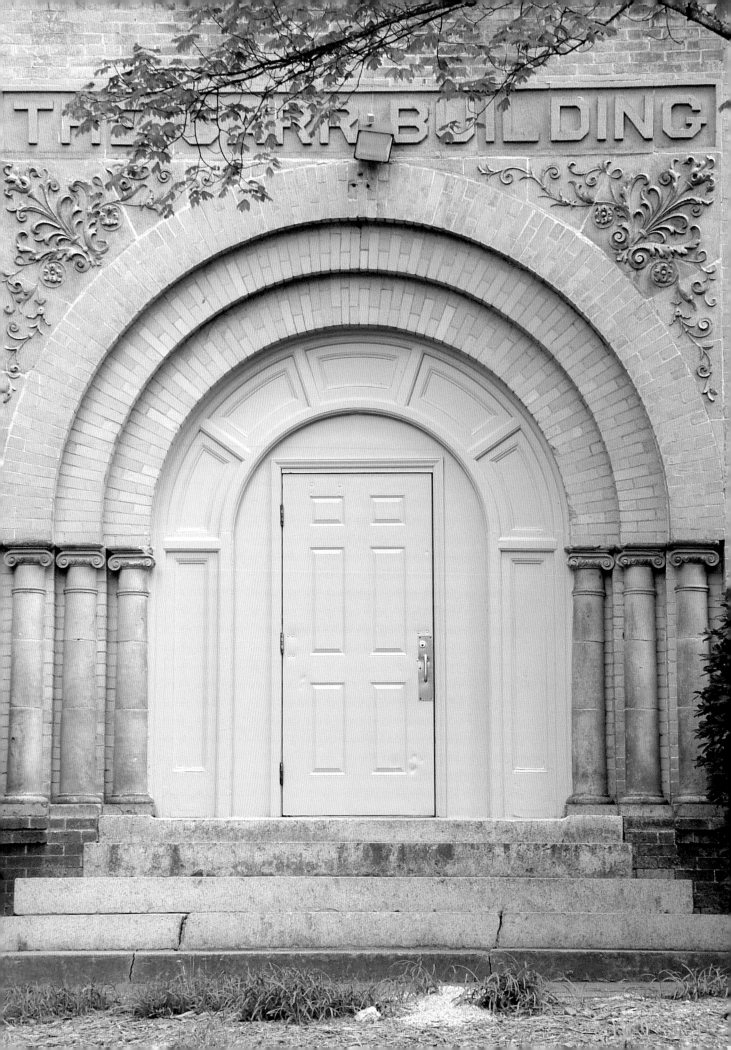

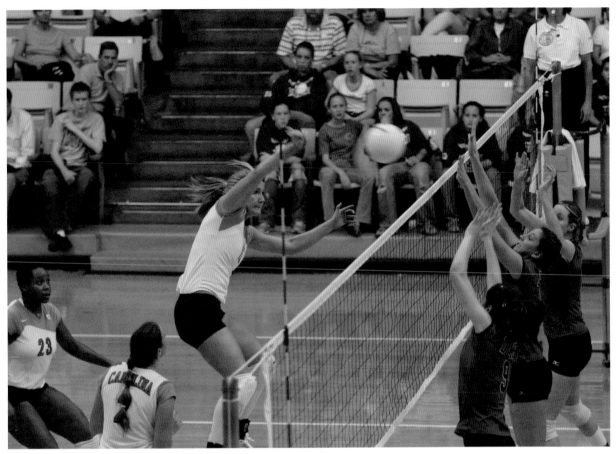

Women's varsity volleyball in Carmichael Auditorium.
Photograph by Brandon Smith.

Sweetly ornamented, Carr Building
hearkens back to a more fanciful style
of architecture.
Photograph by Gary Simpson.

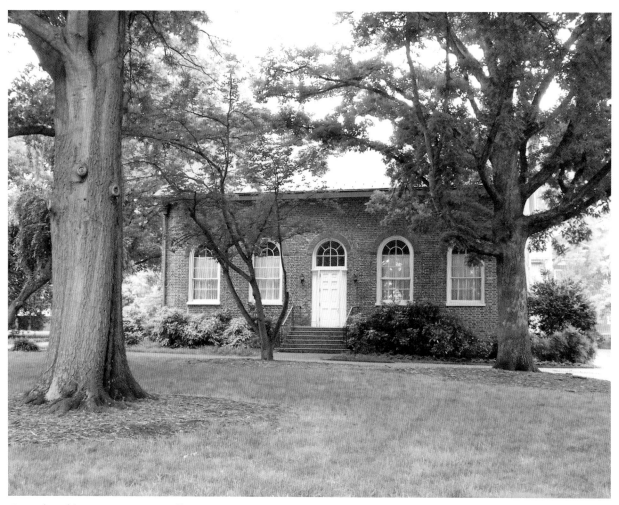

Completed in 1797, Person Hall was originally built as a chapel, then housed chemistry labs, and now serves as a performance space for the Music Department. It is also home to several protective university gargoyles.

Photographs by Stacie Smith.

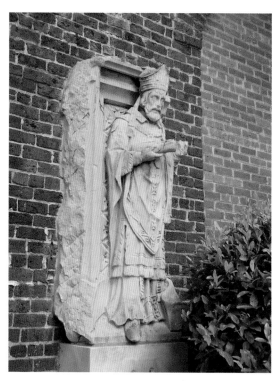

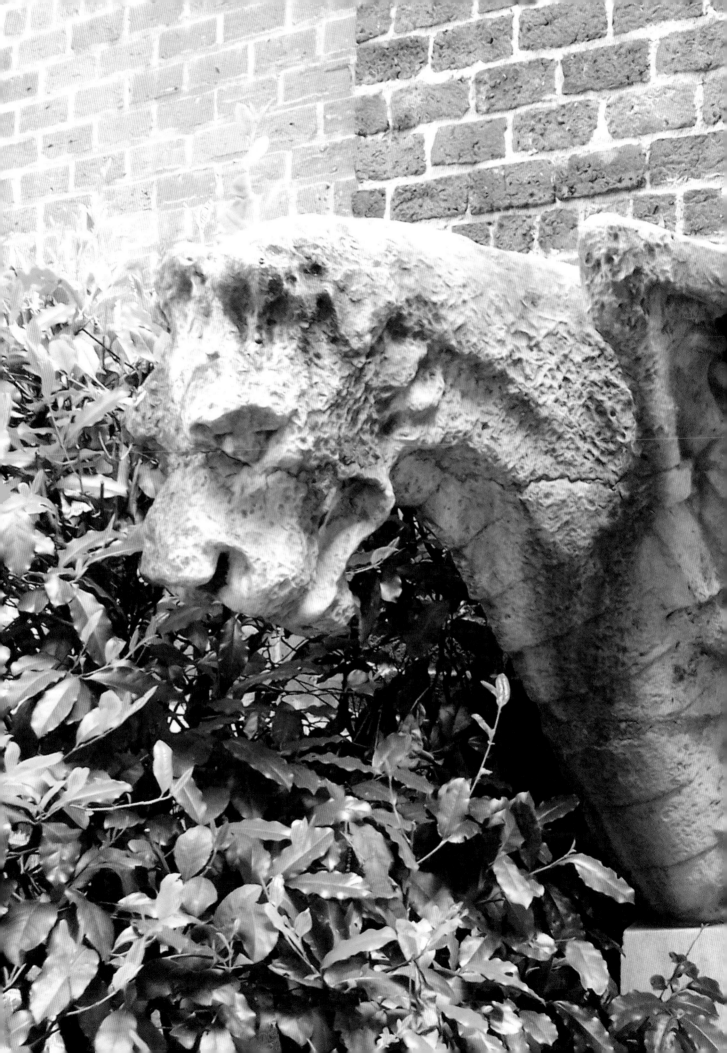

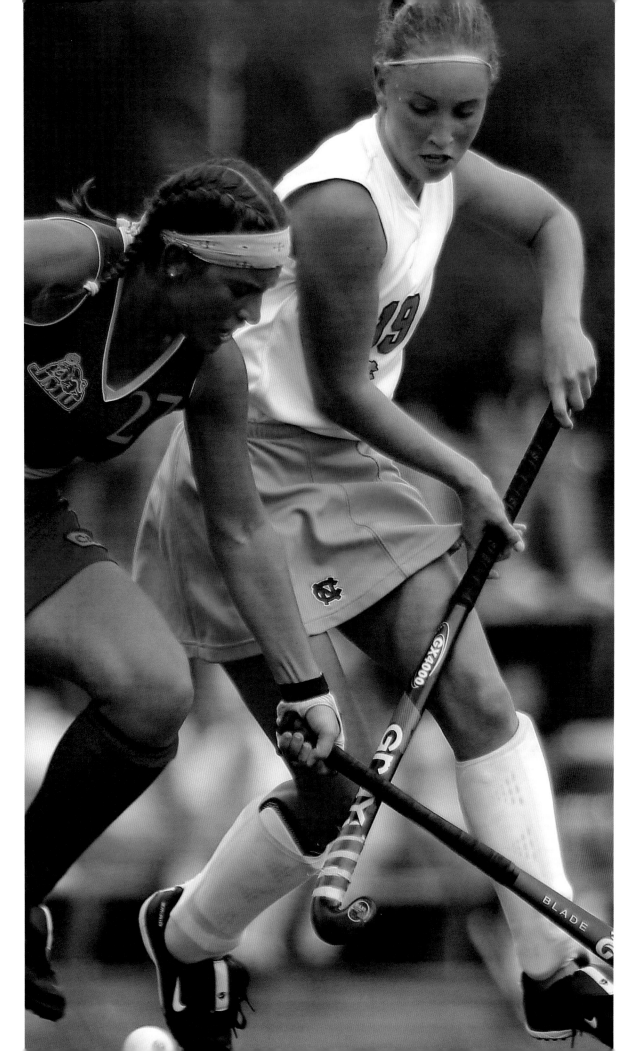

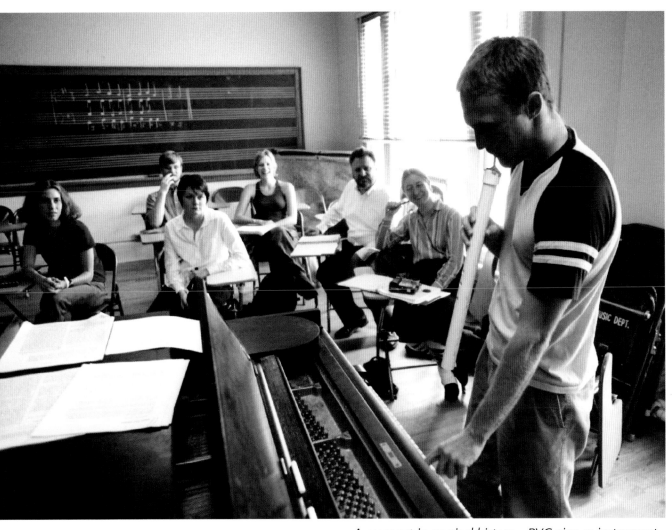

A moment in musical history—PVC pipe as instrument.
Photograph by Dan Sears.

Women's varsity field hockey.
Photograph by Josh Greer.

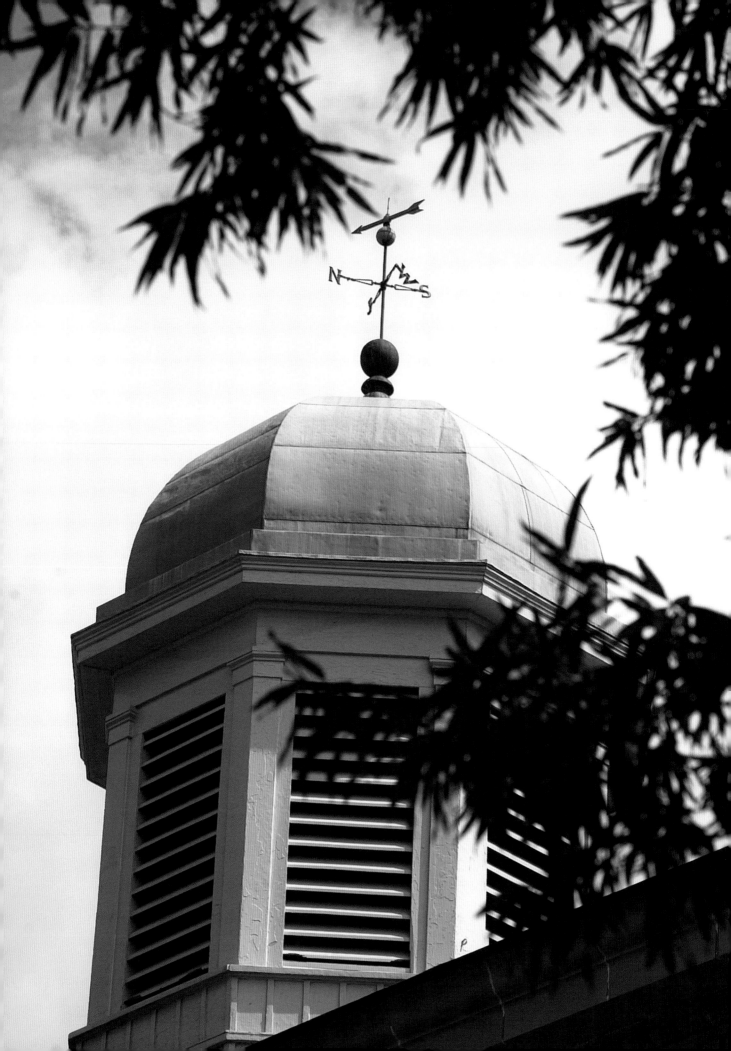

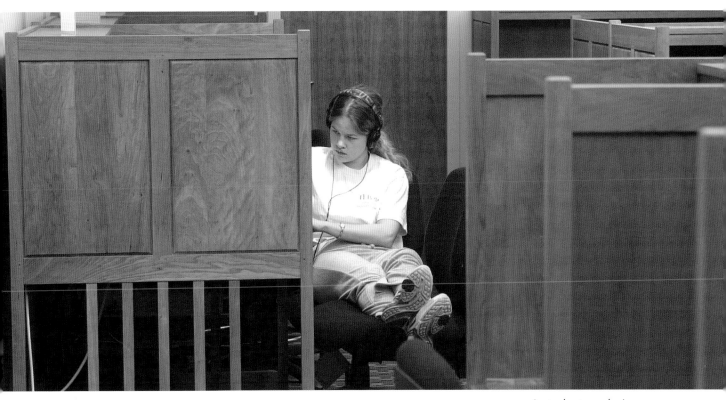

*A student works in
a study carrel at the
Undergraduate Library.*
Photograph by Dan Sears.

*South Building's
beautiful cupola, one
of the most recognized
landmarks on the
Carolina campus.*
Photograph by Dan Sears.

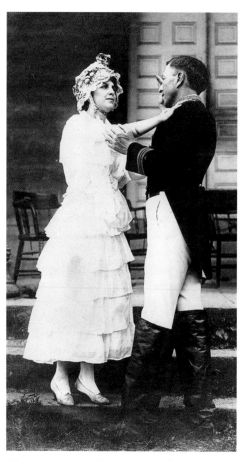

The University of North Carolina has had a long love affair with the theater. Here, a 1918 ingenue and her co-star pose on the steps of Playmakers Theatre.
Courtesy of Frank Bellamy.

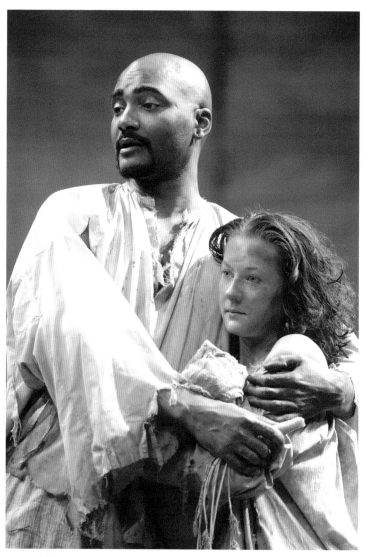

Earl Baker Jr. as Saul Mercer and Melissa Herion as Betty Mercer in PlayMakers Repertory Company's American premiere of Luminosity by Nick Stafford. Photograph by Jon Gardiner, courtesy of PlayMakers Repertory Company.

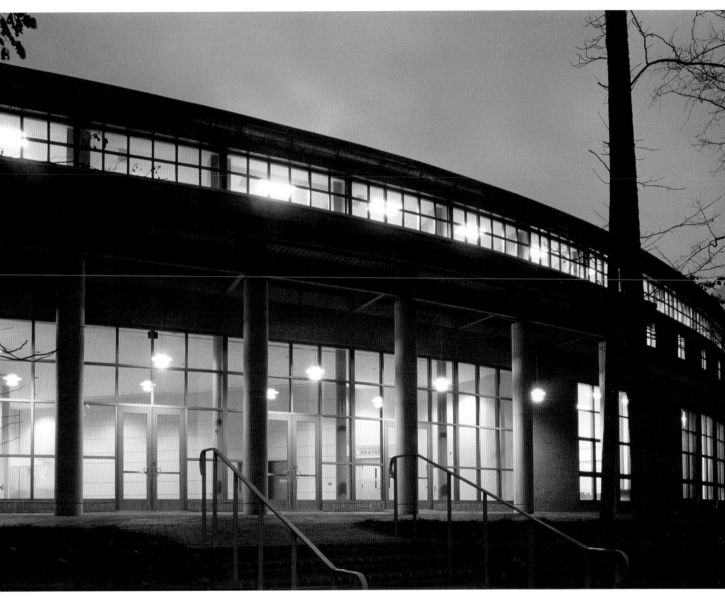

The Center for Dramatic Art, housing the Paul Green Theatre, is the home of PlayMakers Repertory Company, one of the most popular regional theaters in the country. *Photograph by Jonathan Hillyer.*

Graham Memorial Building, named for former university president Edward Kidder Graham, housed UNC's first student union and a popular pool hall. The building is now home to the James M. Johnston Center for Undergraduate Excellence. *Courtesy of the North Carolina Collection, University of North Carolina at Chapel Hill Library.*

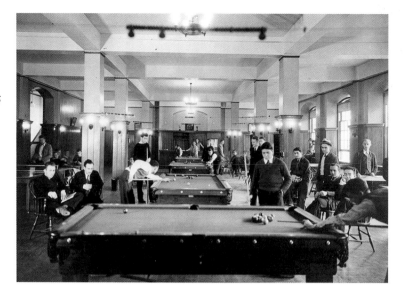

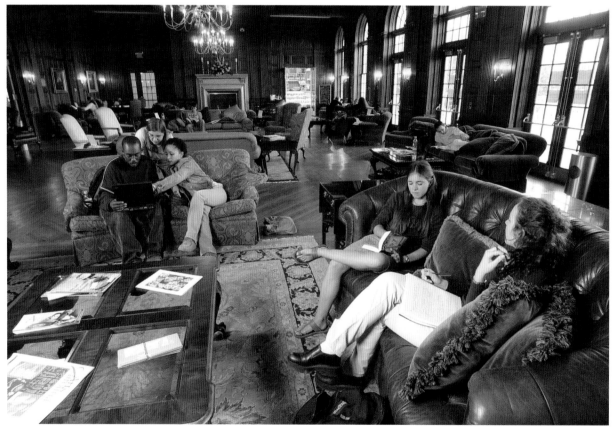

The Johnston Reading Room in Graham Memorial Building offers a perfect place to study, drink coffee, and sometimes, thanks to the comfortable, overstuffed chairs, nap. *Photograph by Dan Sears.*

"The Gift," a mosaic of American Indian symbols created by Haliwa-Saponi artist Senora Lynch, paves the walkway between the old and new wings of the Frank Porter Graham Student Union. Here, the mosaic and the play of sunlight and shadow result in a marvel of pattern. *Photograph by Dan Sears.*

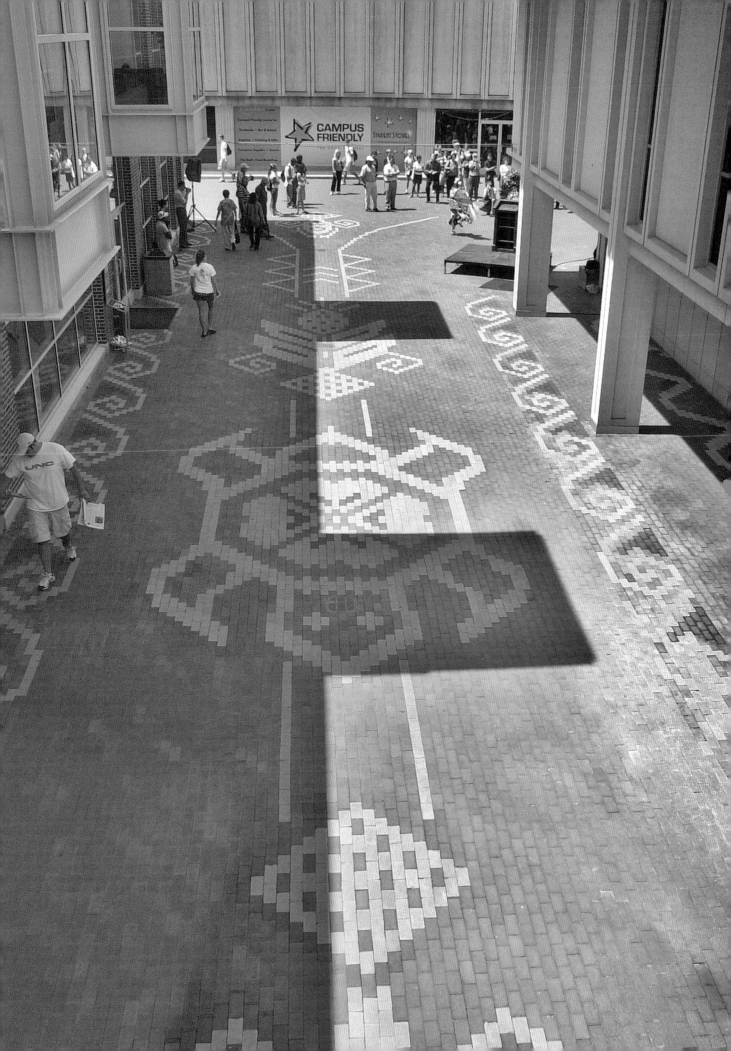

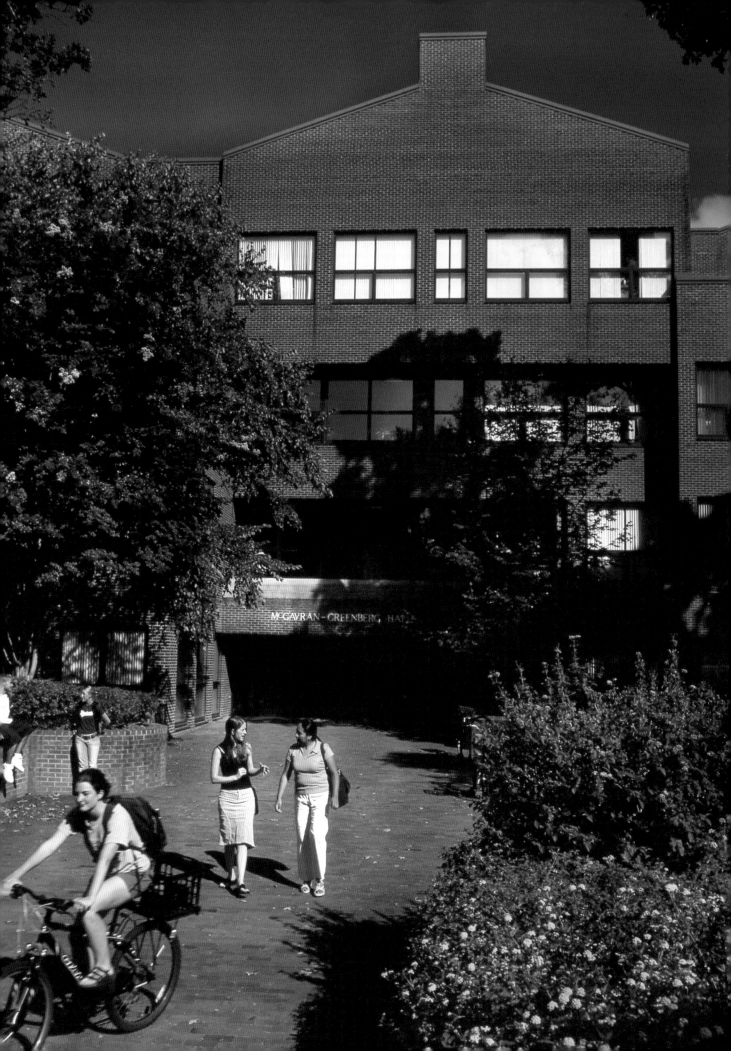

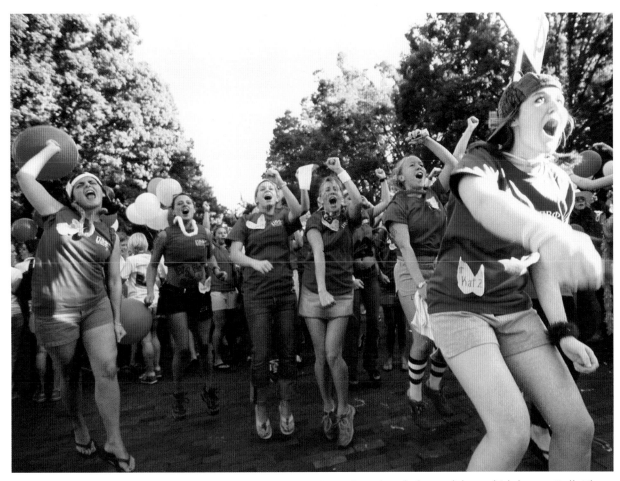

Sorority pledges celebrate bid day on Polk Place.
Photograph by Josh Greer.

*McGavran-Greenberg Hall is
home to UNC's School of Public
Health, which is consistently ranked
among the best in the nation.*
Photograph by Will Owens.

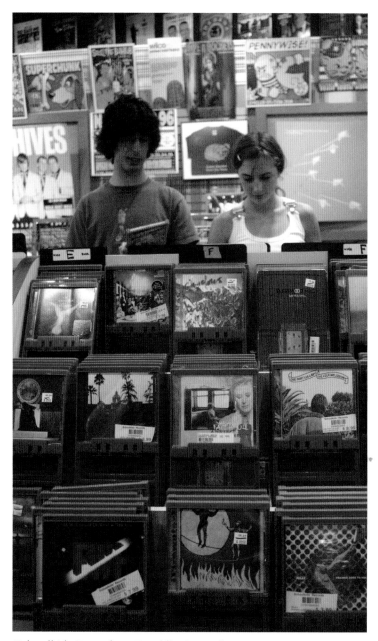

Schoolkids Records, a Franklin Street hot
spot for schoolkids with a yen for music.
Photograph by Garrett Hall.

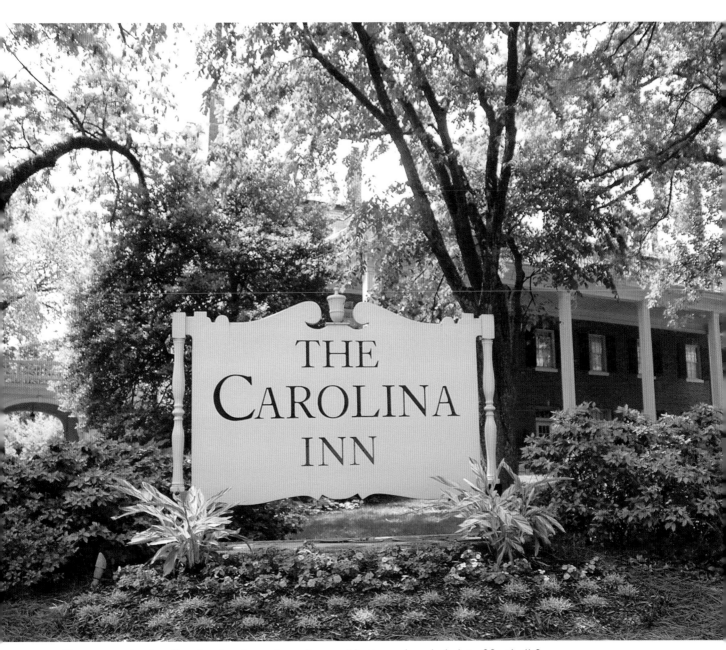

Since 1924, the Carolina Inn has hosted royalty, presidents, and a whole lot of football fans.
Photograph by Gary Simpson.

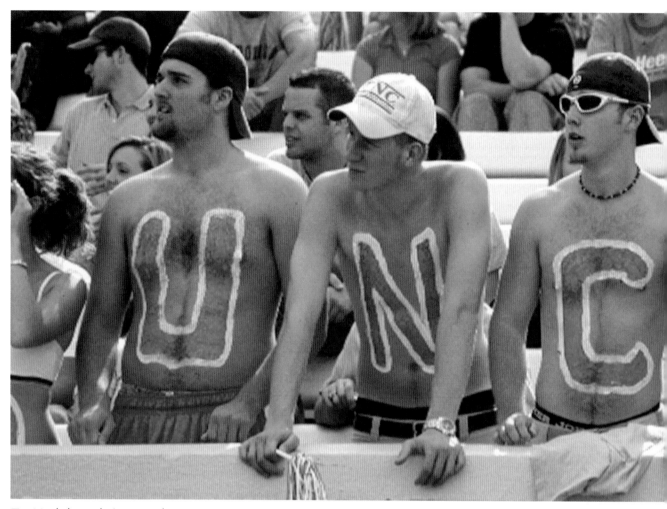

Tar Heels bare their true colors.
Photograph by Carolyn Hack.

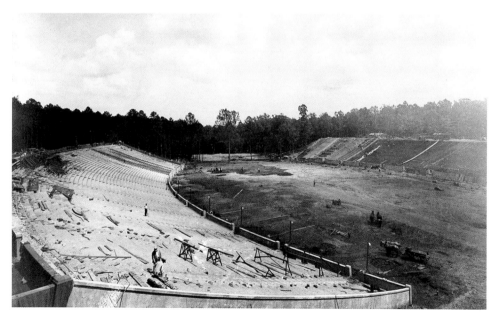

The building of Kenan Stadium, home to Carolina football since 1927.
Courtesy of the North Carolina Collection, University of North Carolina at Chapel Hill Library.

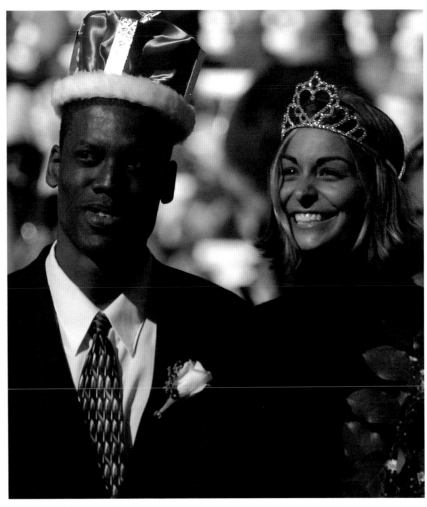

Homecoming royalty.
Photograph by Coke Whitworth.

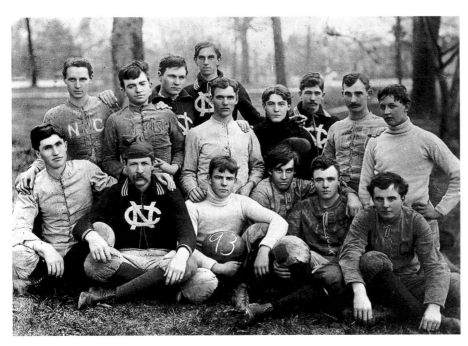

The 1893 Carolina football team was the first to award varsity letters. Courtesy of the North Carolina Collection, University of North Carolina at Chapel Hill Library.

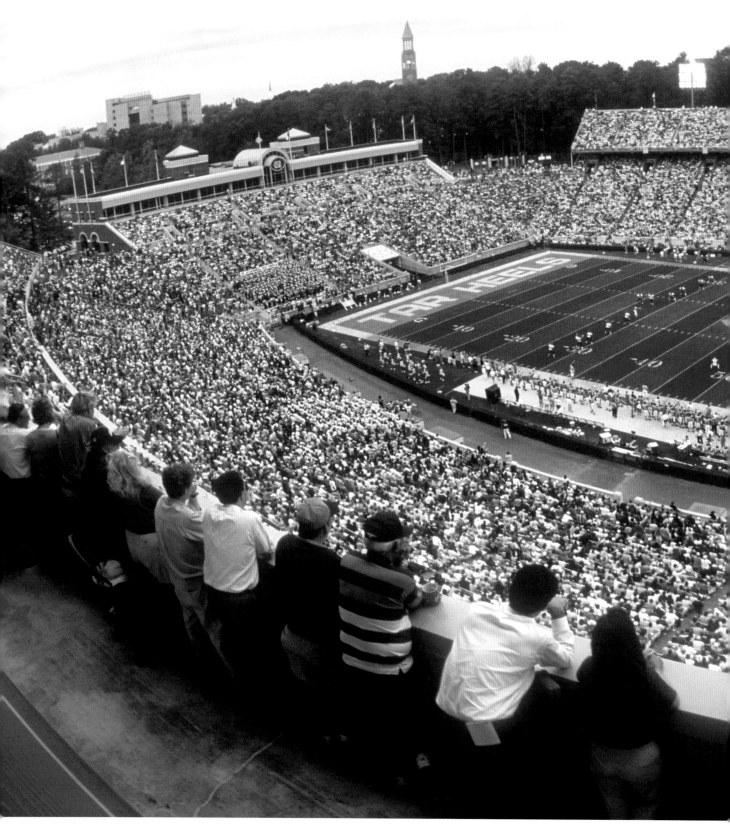

Game day at Kenan Stadium.
Photograph by Hugh Morton.

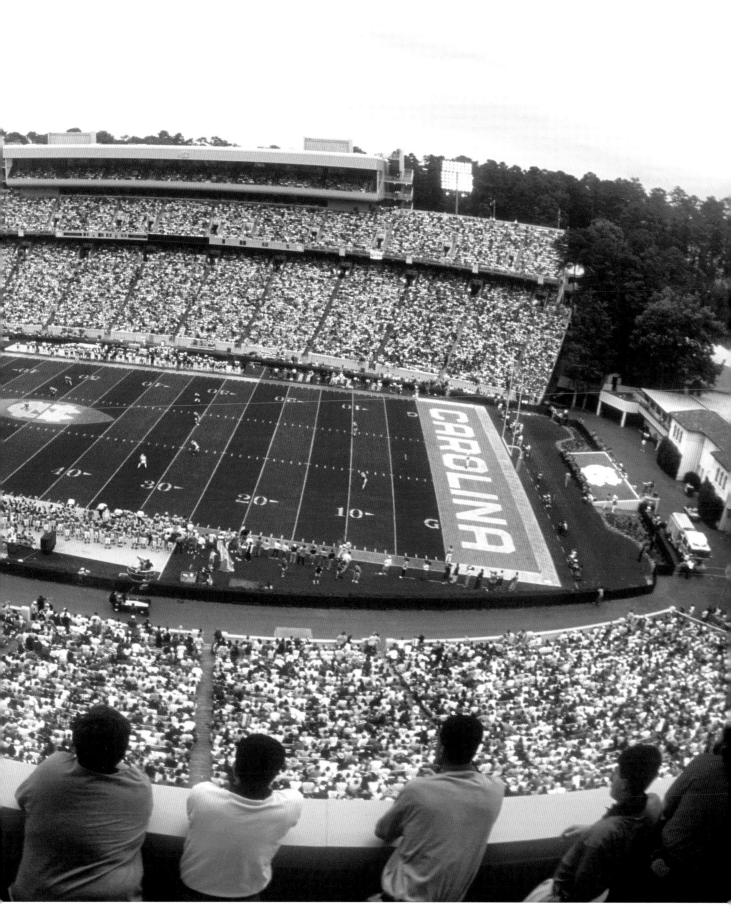

"The Pride of the ACC," the Marching Tar Heels. Photograph by Coke Whitworth.

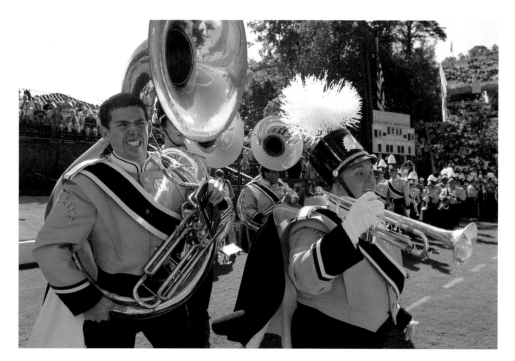

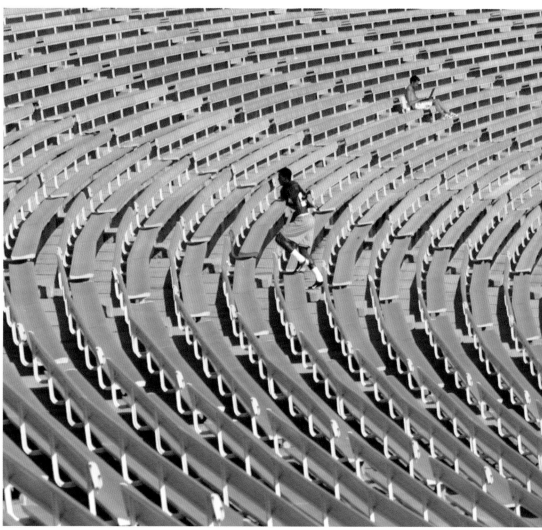

How do you get to Kenan Stadium? Practice, practice, practice.
Photograph by Nancy Donaldson.

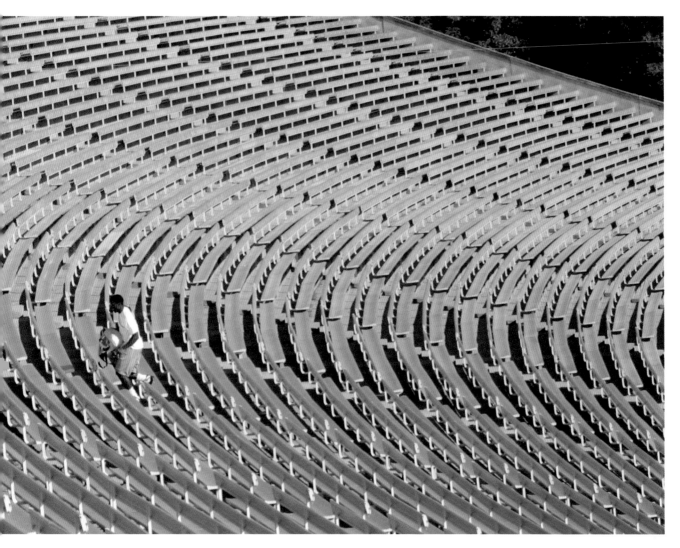

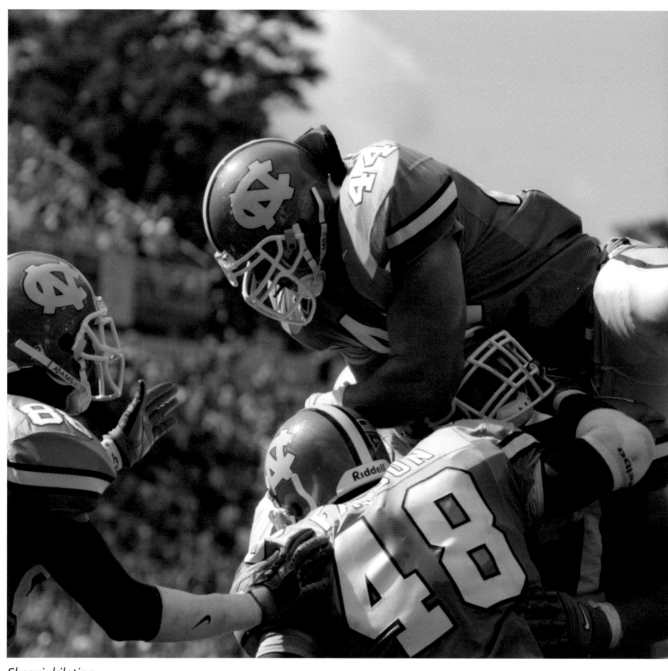

Sheer jubilation.
Photograph by Jeffrey Camarati, *courtesy of UNC Department of Athletics.*

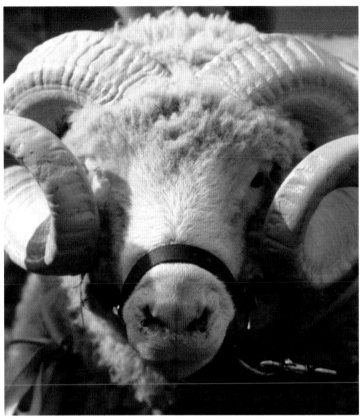

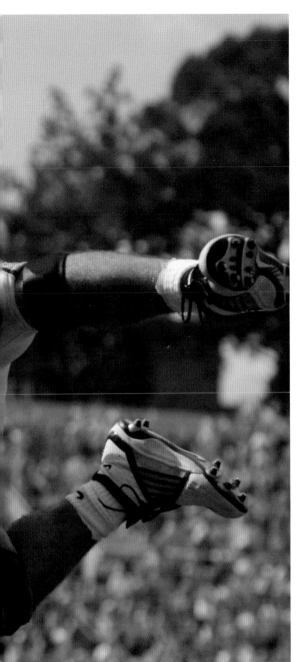

Ramses, the Carolina mascot, watches from the sidelines of every home football game. The original Ramses came to Chapel Hill in 1924, when star player Jack "Battering Ram" Merrit inspired cheerleaders to suggest the mascot for the university.

Photograph by Kim Rowland.

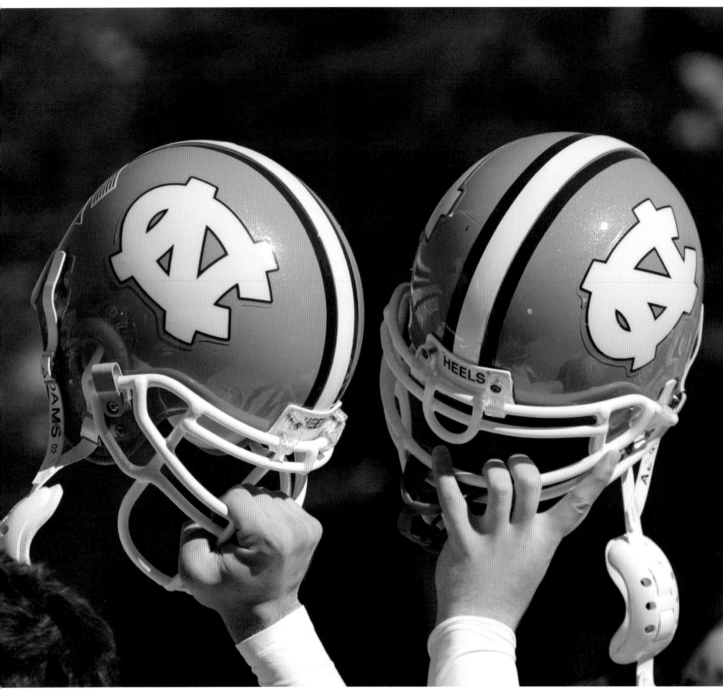

Helmets held high.
Courtesy of UNC Athletic Communications.

Bringing down the goalposts.
Photograph by Jeffrey Camarati.

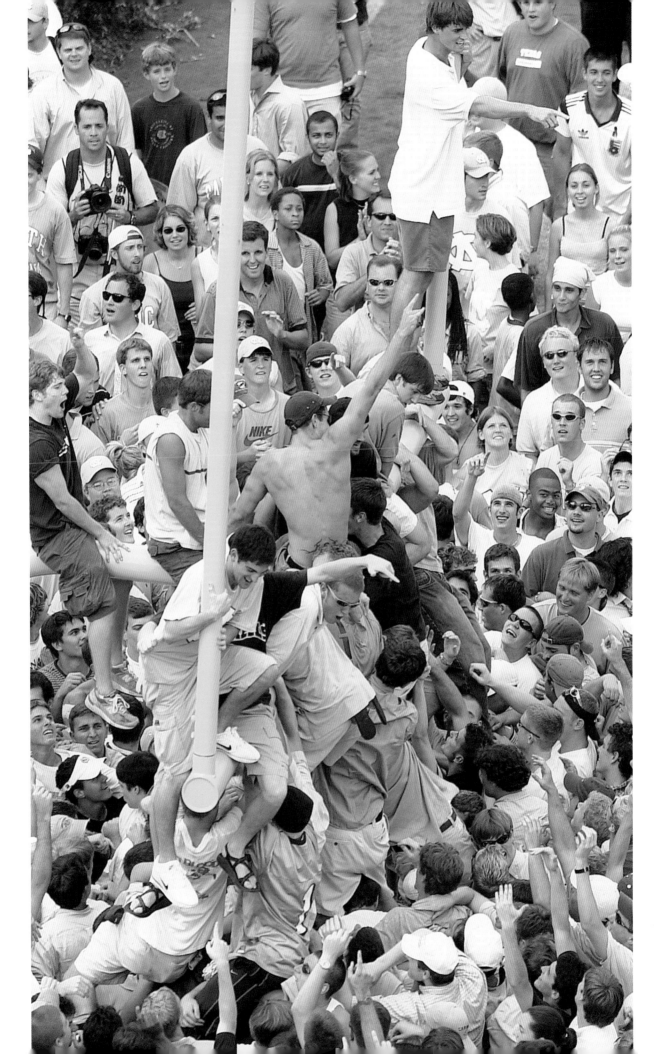

The magical All-American Charlie "Choo-Choo" Justice earned his fame on the football field, where he led the Tar Heels to three major bowl appearances in four years between 1946 and 1949. When Benny Goodman recorded "All The Way Choo-Choo," the song immortalizing Justice's exploits became a nationwide hit.
Photograph by Hugh Morton.

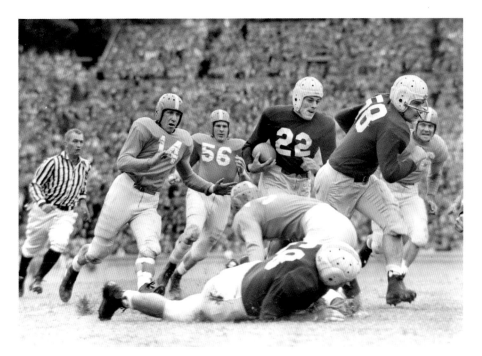

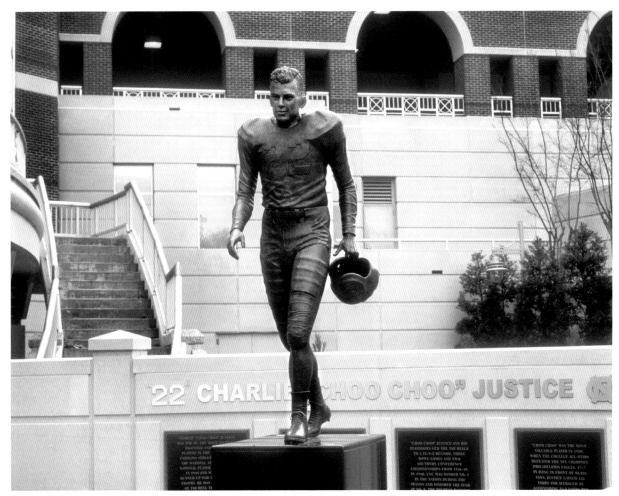

A statue honoring Charlie Justice, unveiled in 2004, now greets visitors to the Kenan Football Center.
Photograph by Hugh Morton.

Cheerleaders lead the traditional postgame singing of "Hark the Sound," Carolina's alma mater.
Photograph by Carolyn Hack.

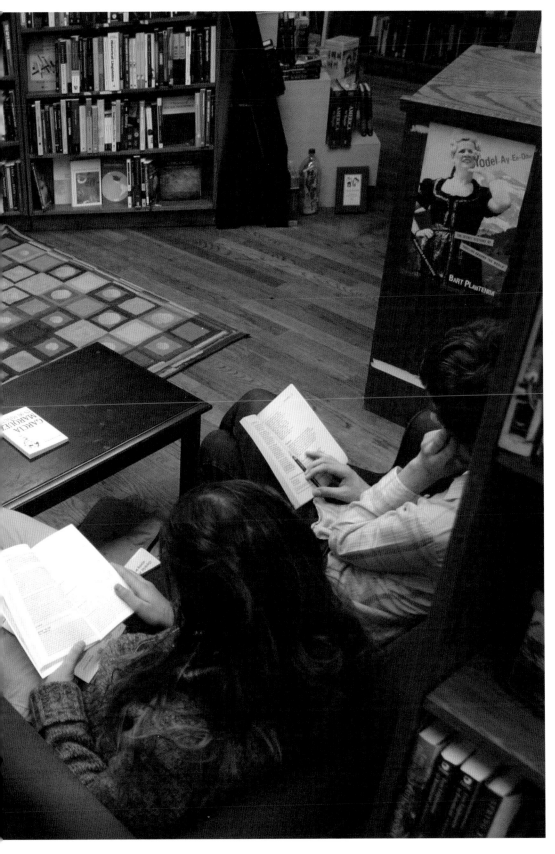

The Bull's Head
Bookshop, a
campus institution
since 1925, is the
perfect quiet place
on campus to read
a good book—or
the latest edition
of the Daily Tar
Heel.
Photograph by
Andrew Synowiez.

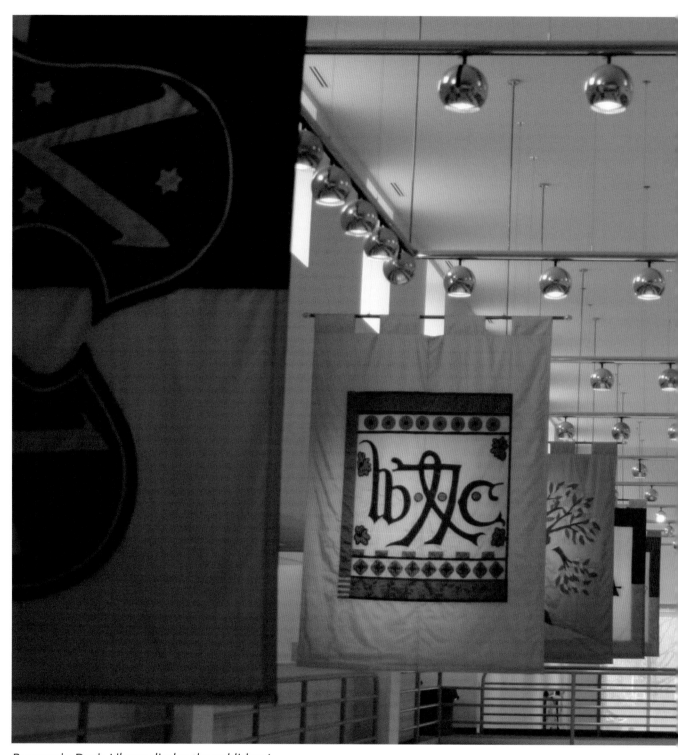

Banners in Davis Library display the publishers'
"devices," or trademarks, of presses represented
in the campus's esteemed Rare Book Collection.
Photograph by Kim Rowland.

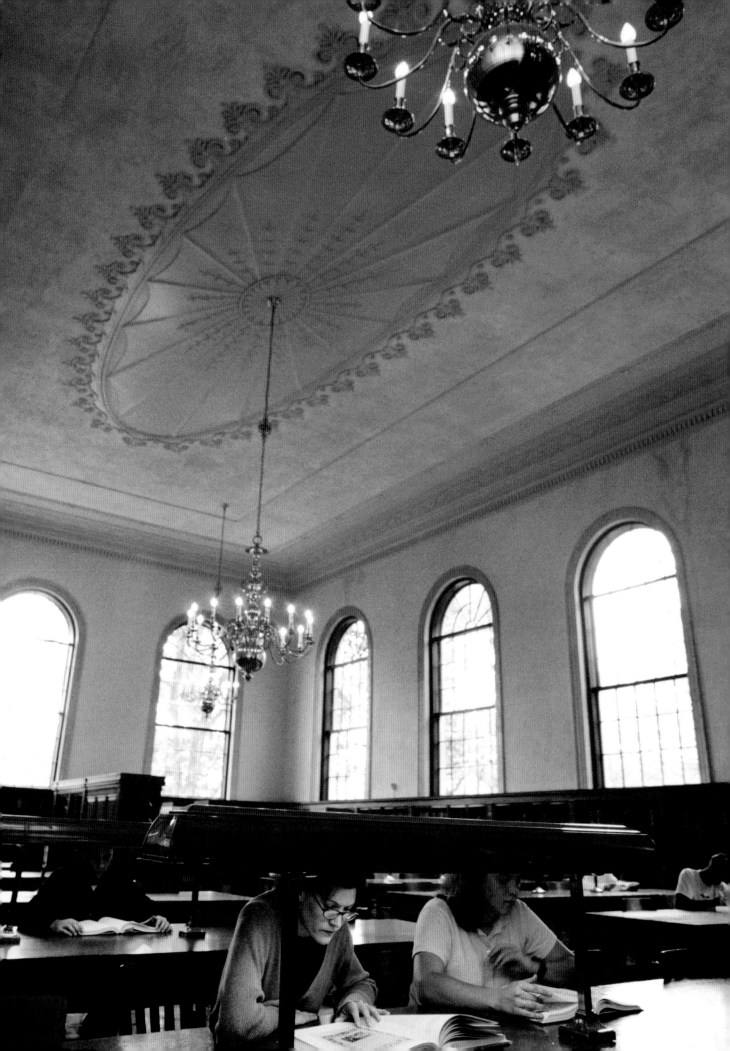

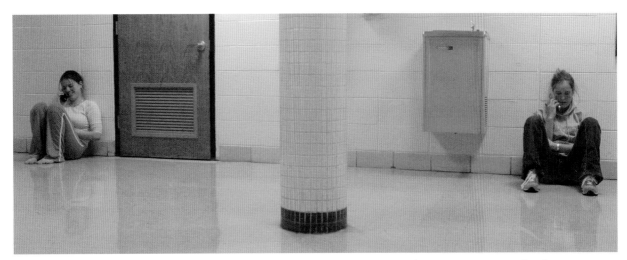

South Campus communication.
Photograph by Samkit Shah.

"I've never gotten over the first time I entered Wilson Library. I never knew there were so many books in the world." —Shelby Foote.
Photograph by Dan Sears.

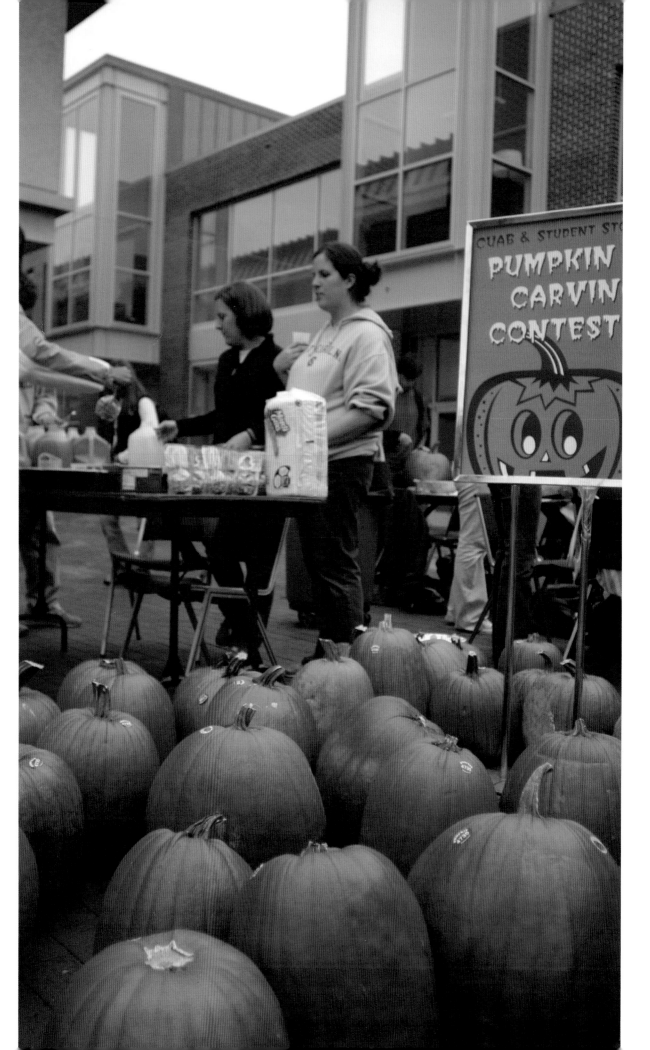

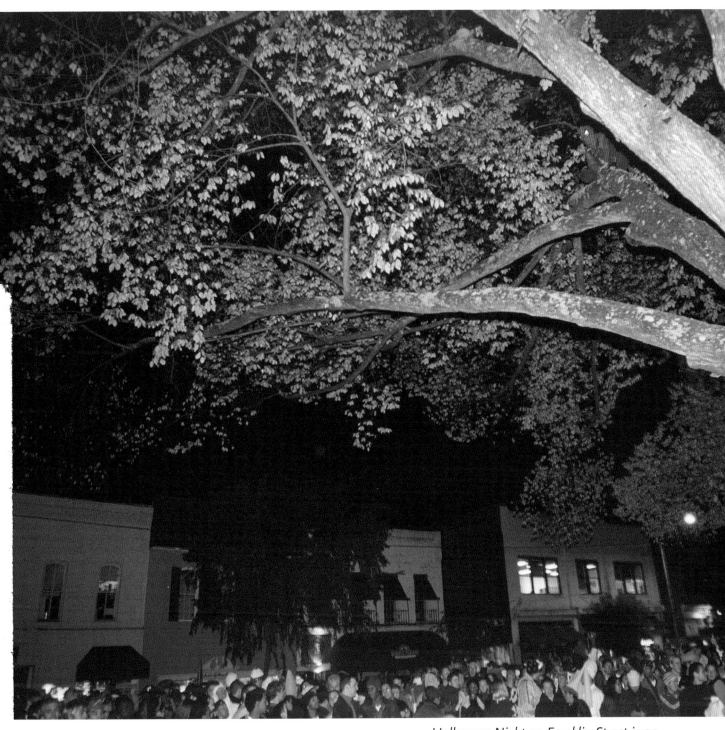

Halloween Night on Franklin Street is an event of almost frightening proportions.
Photograph by Josh Greer.

The Carolina Union Activities Board's many events always attract the sharpest students. Photograph by John Dudley.

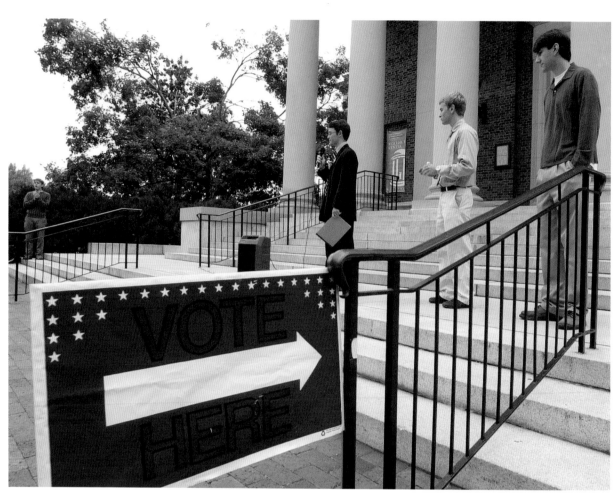

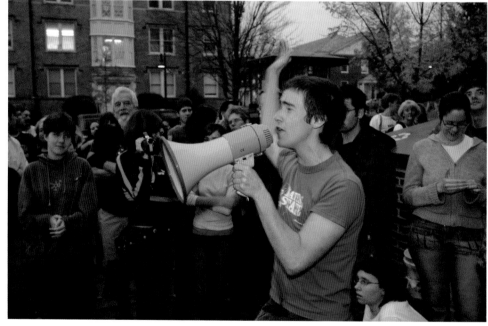

Students run "no-excuses voting" on the steps of Morehead Planetarium.
Photograph by Dan Sears.

A hallmark of a vibrant campus—politicized students.
Photograph by Brandon Smith.

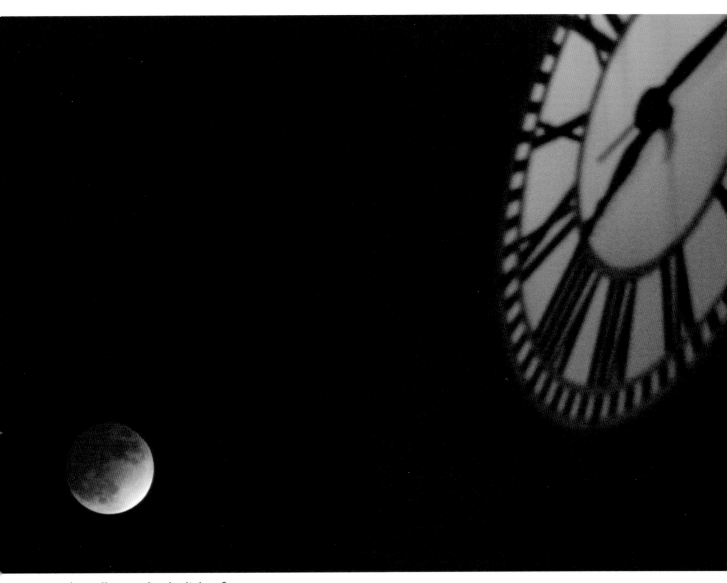

The Bell Tower by the light of an autumn moon.
Photograph by Justin Smith.

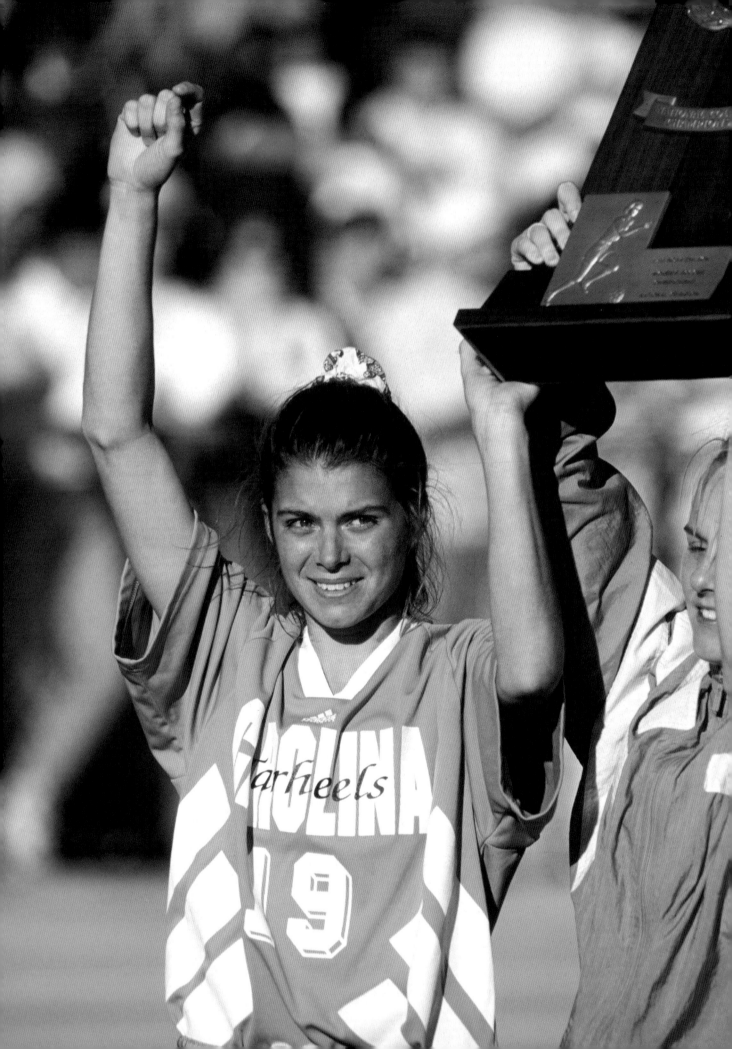

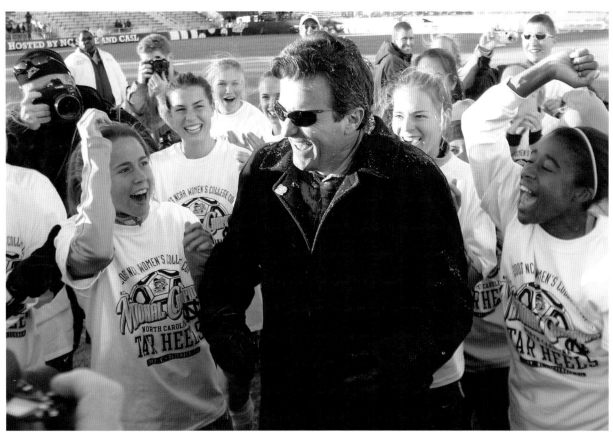

When asked about the school's reputation as a basketball powerhouse, Dean Smith once famously quipped that he thought the university was a women's soccer school. With coach Anson Dorrance leading the Tar Heels to national championships year after year, who could blame Smith for his thinking?
Photograph by Josh Greer.

Women's soccer legend Mia Hamm left campus to become the face of the sport worldwide. Those who saw her play at Carolina had plenty of reason to suspect she was destined for greatness.
Photograph by Bob Donnan.

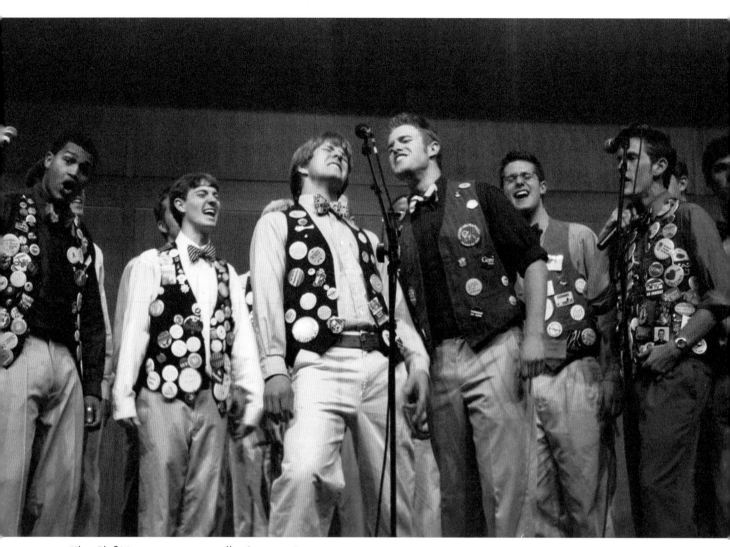

The Clef Hangers—a cappella since 1976.
Photograph by Carolyn Hack.

Dorm rooms change in some ways . . .
and not in others.

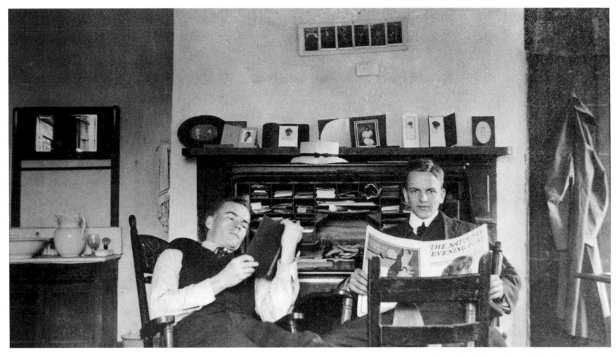

Courtesy of the North Carolina Collection,
University of North Carolina at Chapel Hill Library.

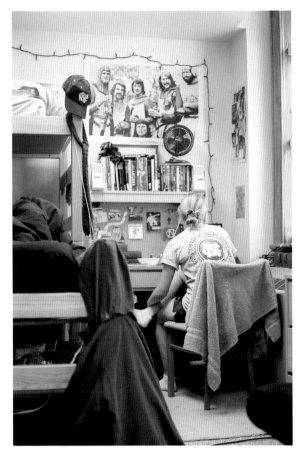

Photograph by Holly Czuba.

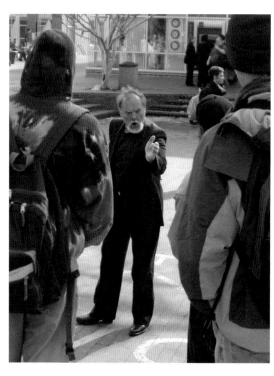

Over the years, the continued presence of "the Pit Preacher" has symbolized Carolina's commitment to free speech.

Photograph by Danielle Wilson.

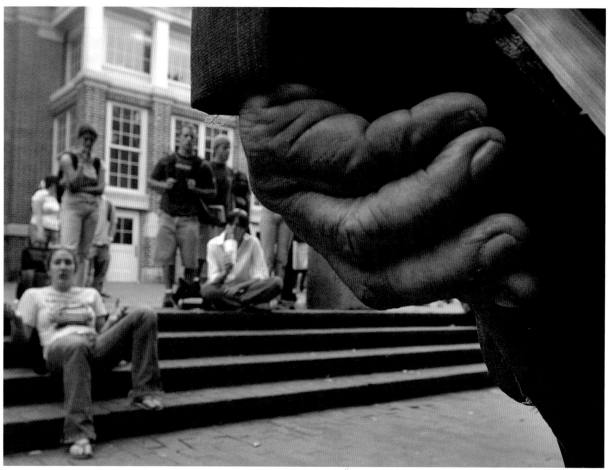

Photograph by Justin Cook.

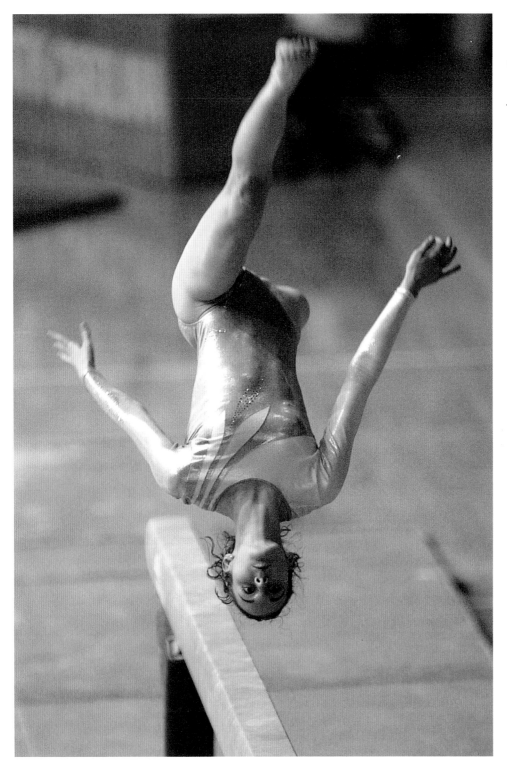

*Women's
varsity
gymnastics.*
Photograph by
Josh Greer.

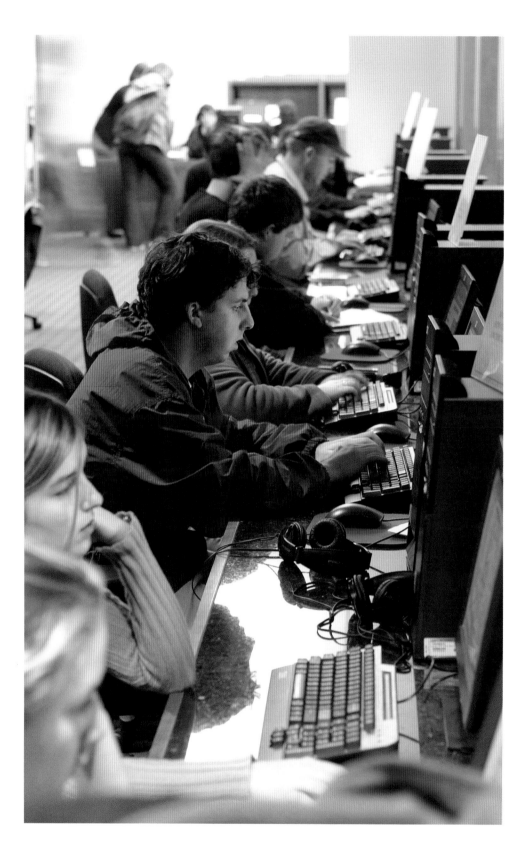

A convenient place to compute on campus.
Photograph by
Dan Sears.

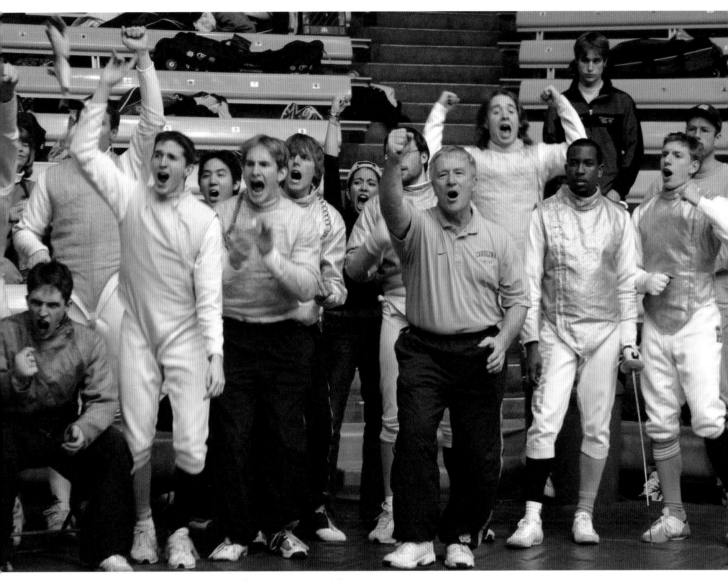

Members of the Carolina varsity fencing team celebrate a win.

Photograph by Carolyn Hack.

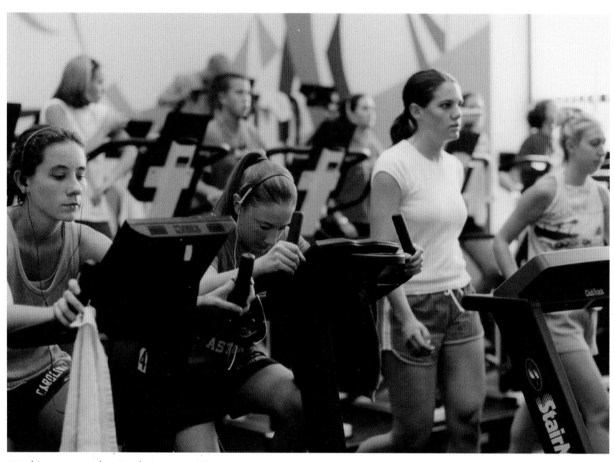

Working out at the Student Recreation Center.
Courtesy of the UNC Student Recreation Center.

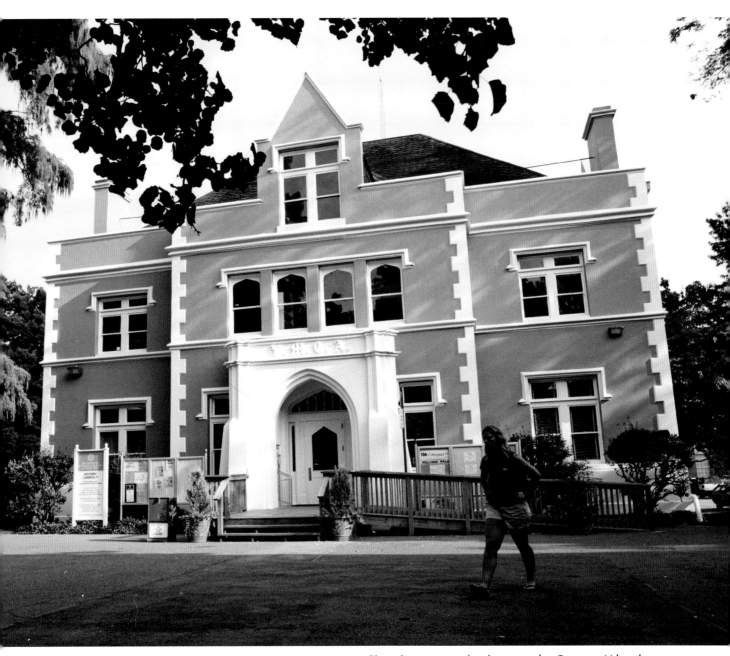

Since its construction in 1907, the Campus Y has been a center for student involvement in social concerns.

Photograph by Dan Sears.

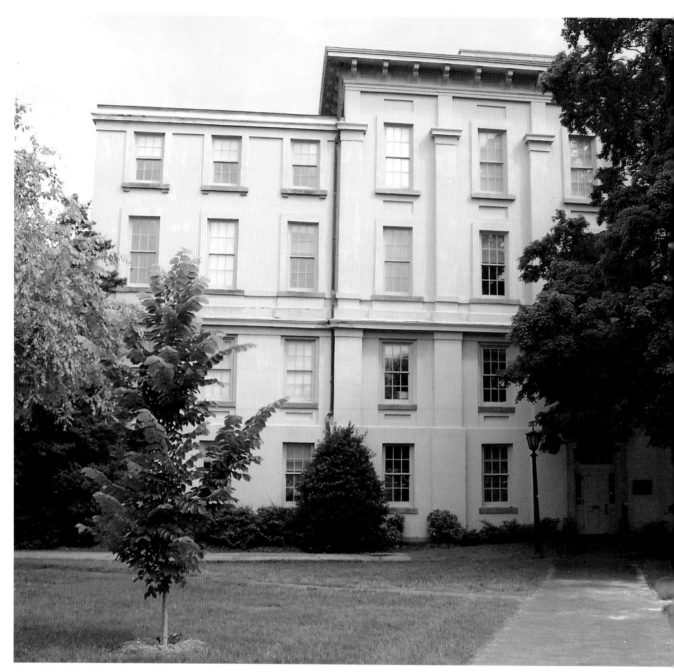

New East Building is hardly new anymore, and like a number
of the campus's older buildings, it has lived many lives. Once
the university's infirmary and medical school, it now houses the
Department of City and Regional Planning, as science programs
migrate toward the southern end of campus.
Photograph by Stacie Smith.

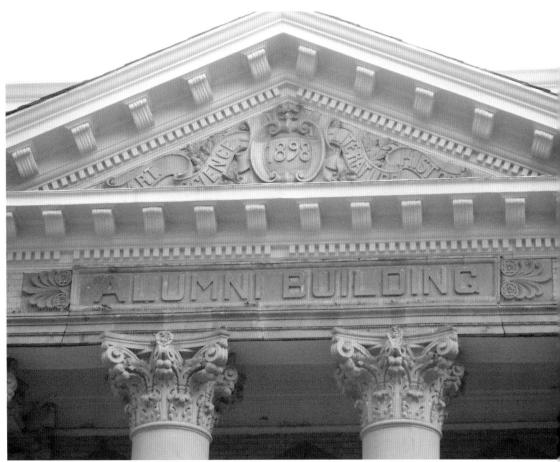

*The pediment atop Alumni Building's Corinthian columns
shows the cornerstones of the university's early curriculum:
art, science, literature, history.* Photograph by Stacie Smith.

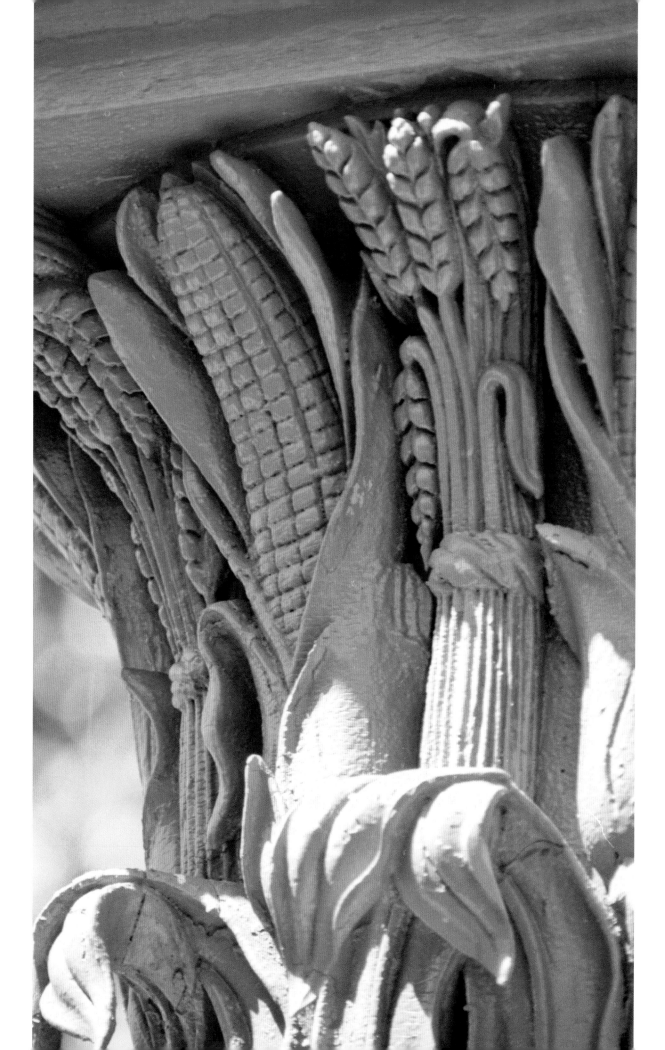

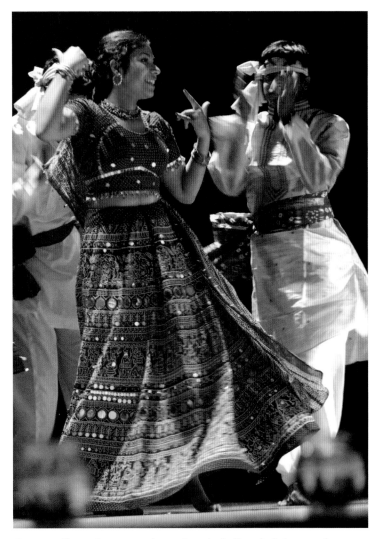

Dancers from Sangam, the university's South Asian student organization, perform in the Great Hall of the Frank Porter Graham Student Union. Photograph by Josh Greer.

In 1851, architect Alexander Jackson Davis, who designed Smith Hall (now Playmakers Theatre), threw tradition to the wind when he topped its Corinthian columns not with acanthus leaves, but with wheat and corn in honor of the United States, then still a young country.
Photograph by Dan Sears.

Members of the Carolina Indian Circle in traditional Native American dress.

Photograph by Catherine Bush.

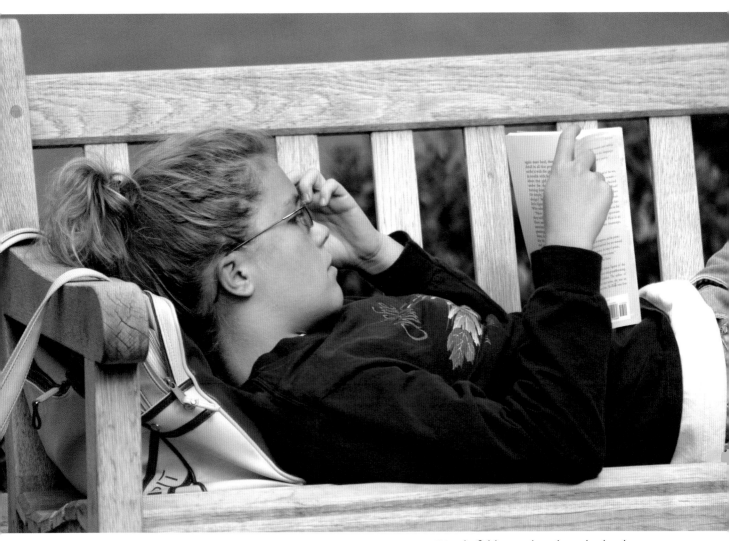

*Wonderful how a bench and a book
can supply a reader with her own world,
even on a busy campus.*
Photograph by Justin Smith.

Steele Building.
Photograph by Dan Sears.

All things point toward a Carolina blue sky.
Photograph by Kansai Graham.

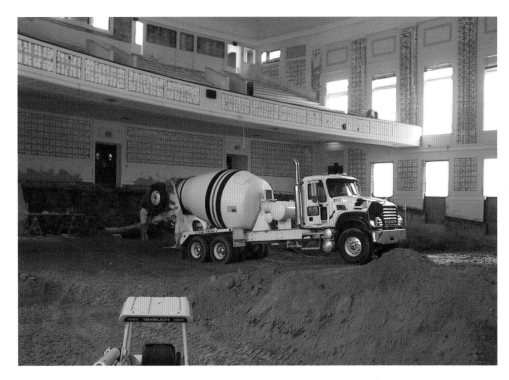

Near-constant construction and renovation on UNC's campus denotes an enthusiasm for progress as well as a respect for the fine old architecture of North Carolina's flagship university.

Photograph by Lindsey Hopkins.

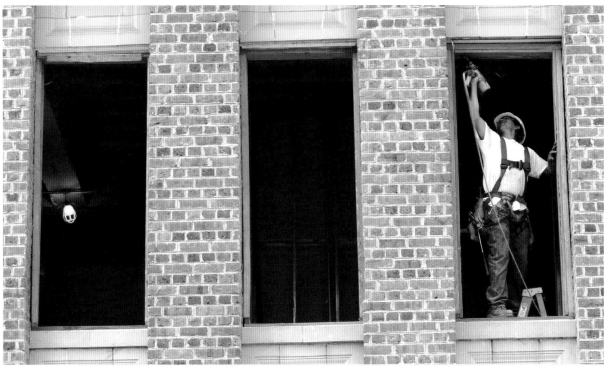

Photograph by Dan Sears.

Some things never change around campus: take the bus, ride your bike, or suffer the consequences.

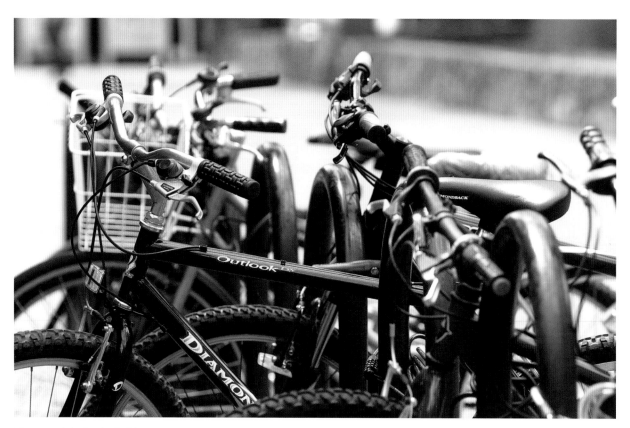

Photograph by Justin Smith.

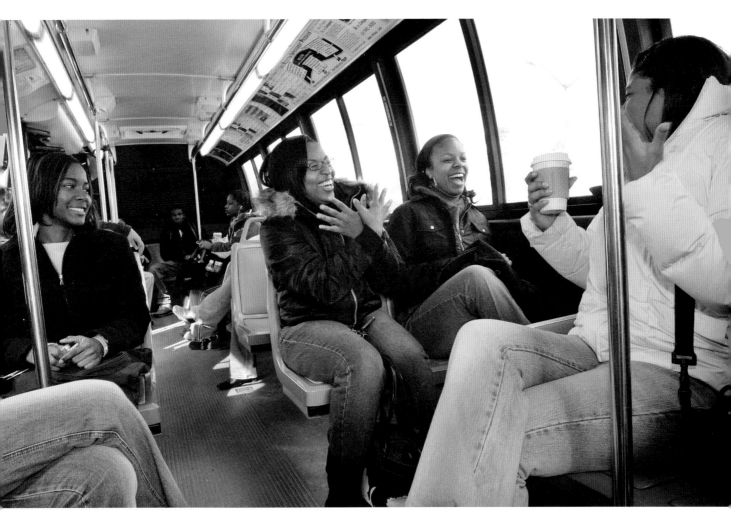

Photograph by Dan Sears.

Courtesy of the
North Carolina Collection,
University of North Carolina
at Chapel Hill Library.

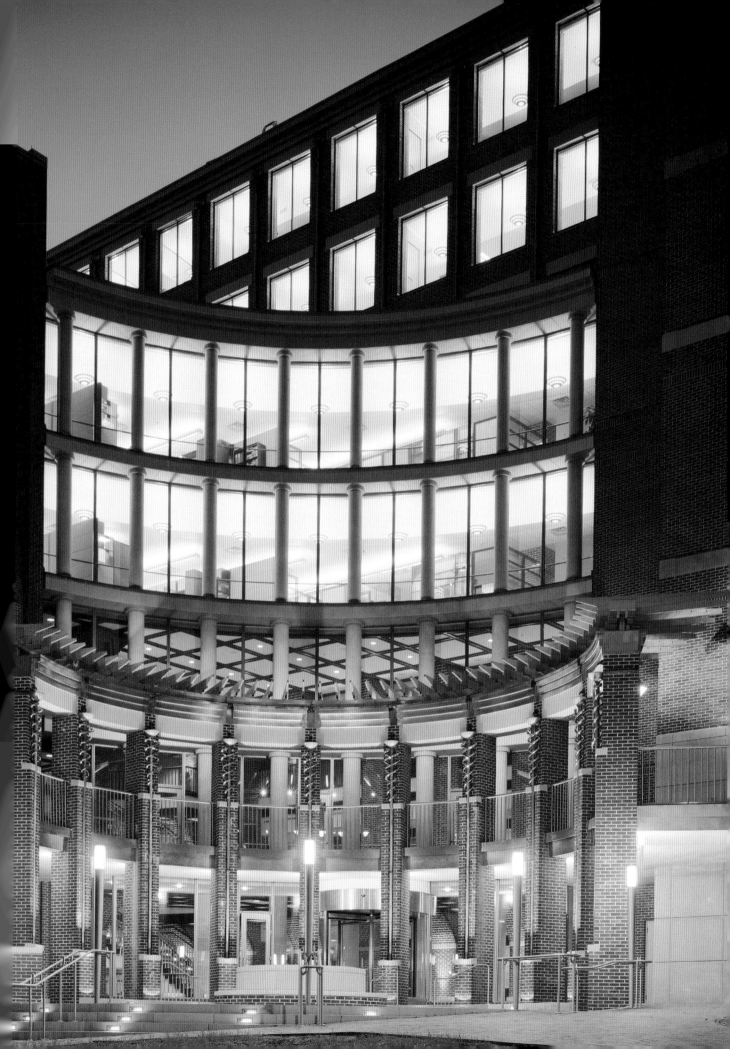

The gleaming Center for Biomolecular Science suggests how far the study of science and medicine has come at Carolina since 1890, when dissections in Dr. Whitehead's first-year anatomy class took place in the wooded area that is now occupied by Wilson Library but was, at the time, away from prying eyes.

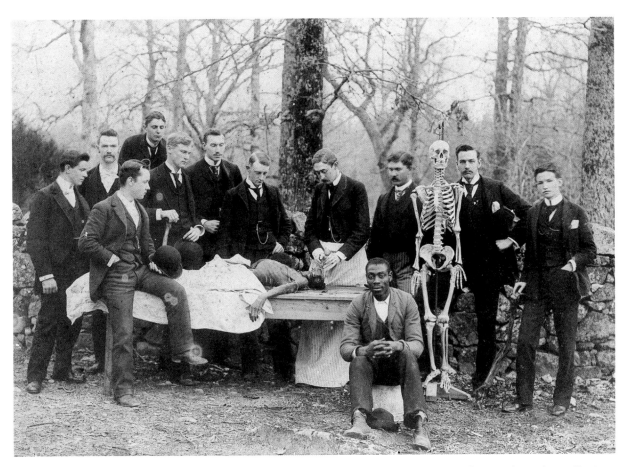

Courtesy of the North Carolina Collection, University of North Carolina at Chapel Hill Library.

Photograph by Jonathan Hillyer.

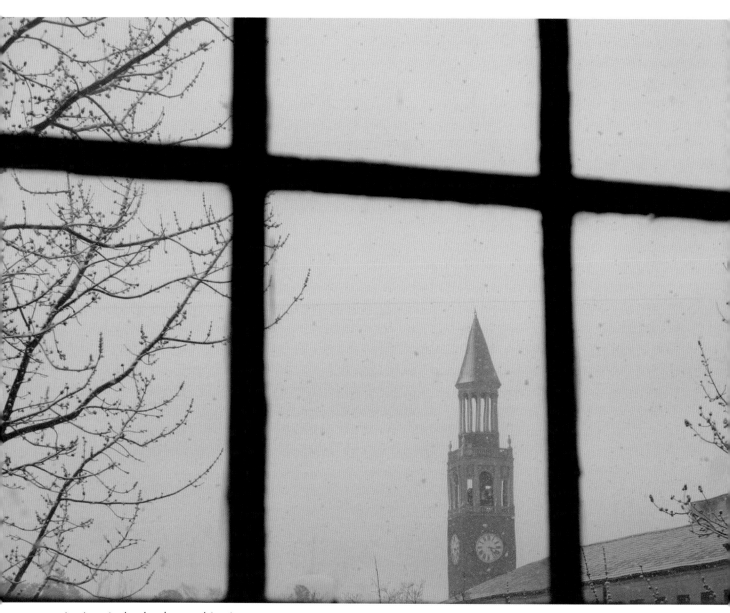

*A winter's day lends a gothic air to
Carolina's usually temperate climes.*
Photograph by Kim Rowland.

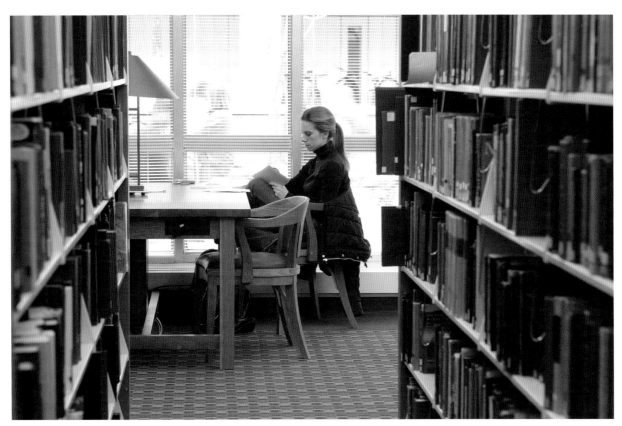

*A student at work in the
Undergraduate Library.*
Photograph by Dan Sears.

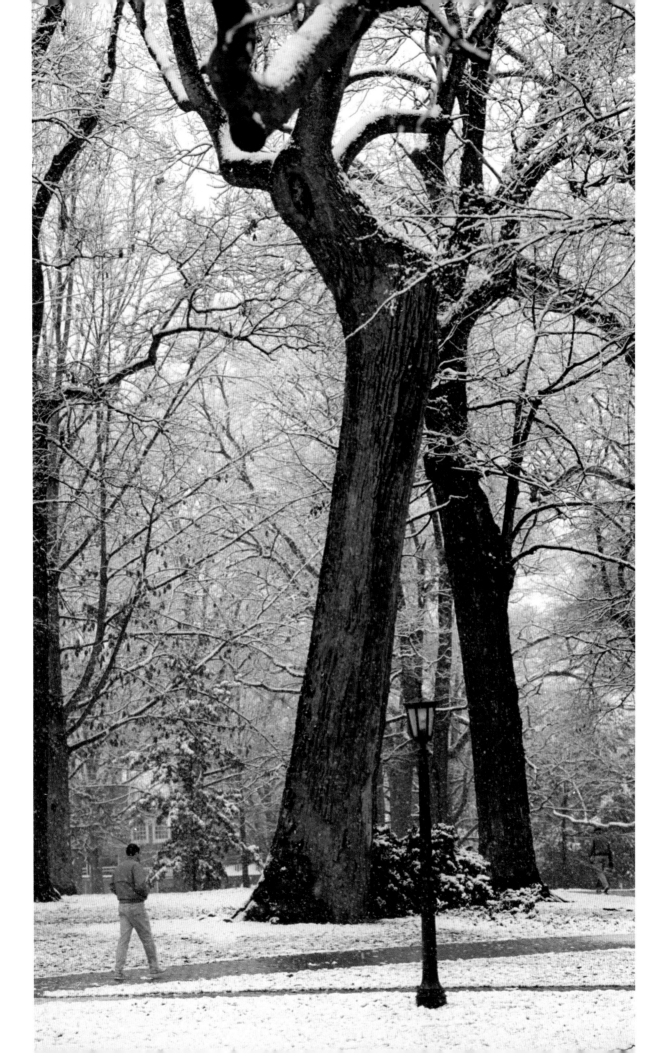

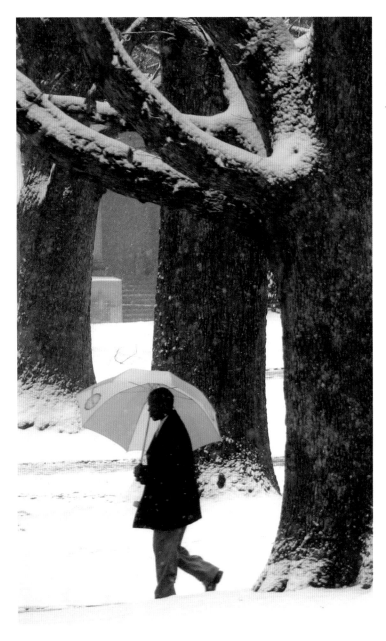

The life of the mind continues, whatever the weather.
Photograph by
Justin Smith.

"As I saw Franklin Street in 1912, it was a dusty red avenue cut through a forest of magnificent trees. My first impression of Chapel Hill was trees, my last impression is of trees. It is no wonder that Chapel Hillians are ardent tree worshippers, and that the symbol of the place is the Davie Poplar."
—Robert B. House.

Photograph by Dan Sears.

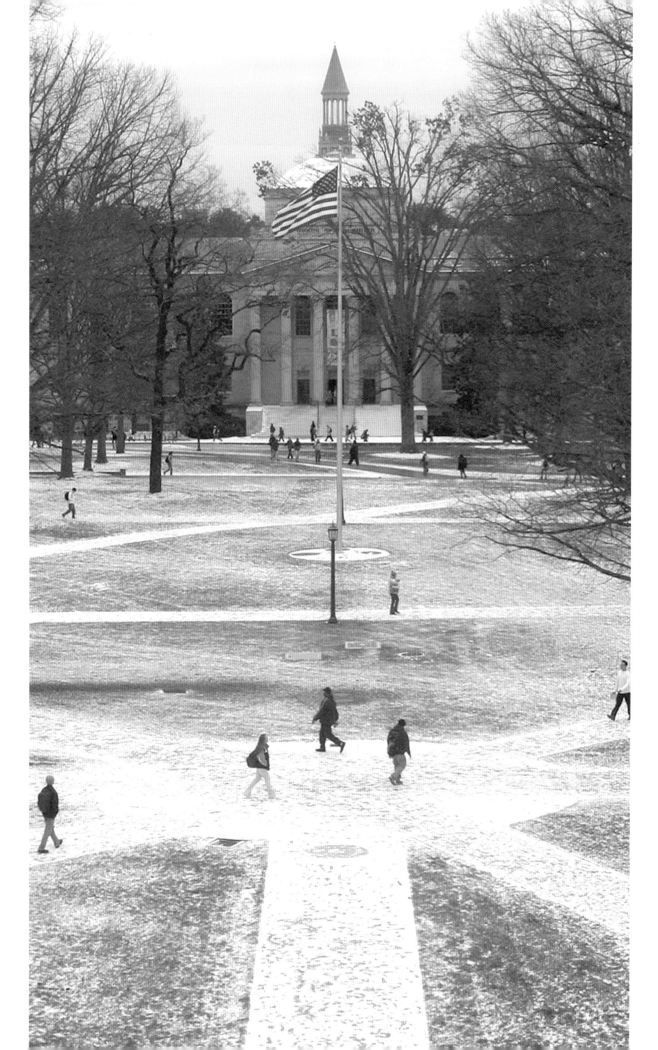

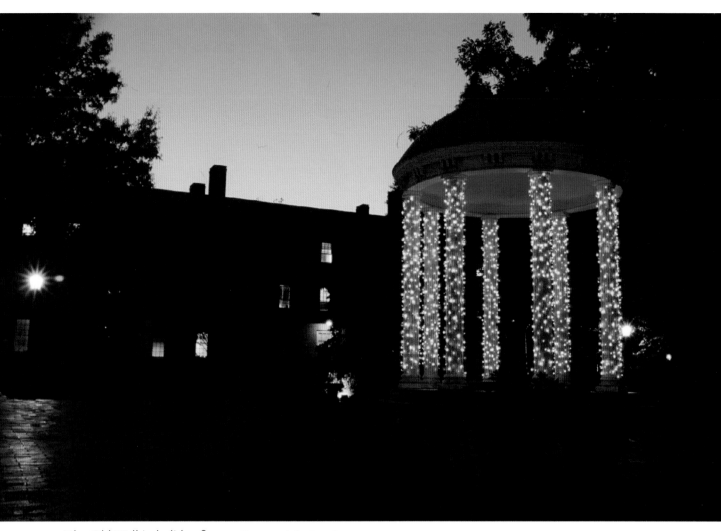

The Old Well in holiday finery. Photograph by Dan Sears.

According to legend, Wilson
Library was built on the very
site that proponents of the Bell
Tower had long desired, on the
south side of Polk Place. In
response, or so the story goes,
the Bell Tower was built just
high enough to give Wilson
Library the appearance, from
certain vantage points, that
it is wearing a dunce cap.
Photograph by Justin Smith.

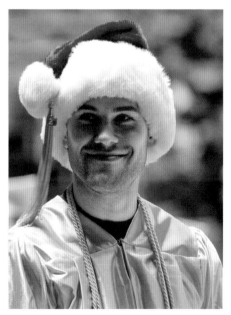

*December commencement—
more than one cause for celebration.*
Photograph by Dan Sears.

*Ticket distribution for basketball games—
sometimes painful, always worth it.*
Photographs by Samkit Shah.

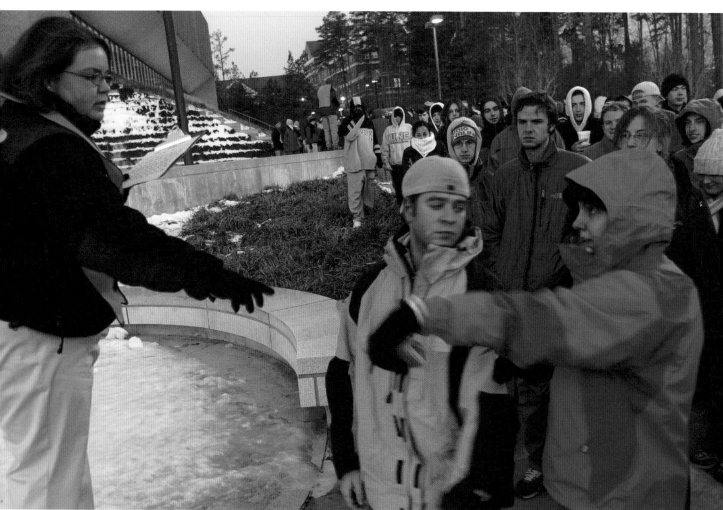

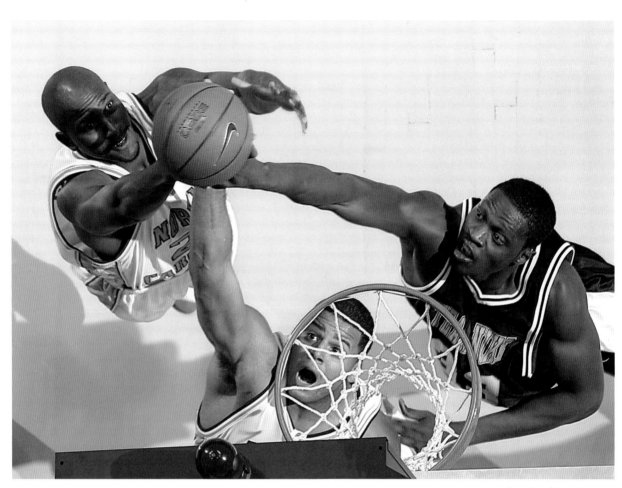

Points in the paint.
Photograph by Josh Greer.

107

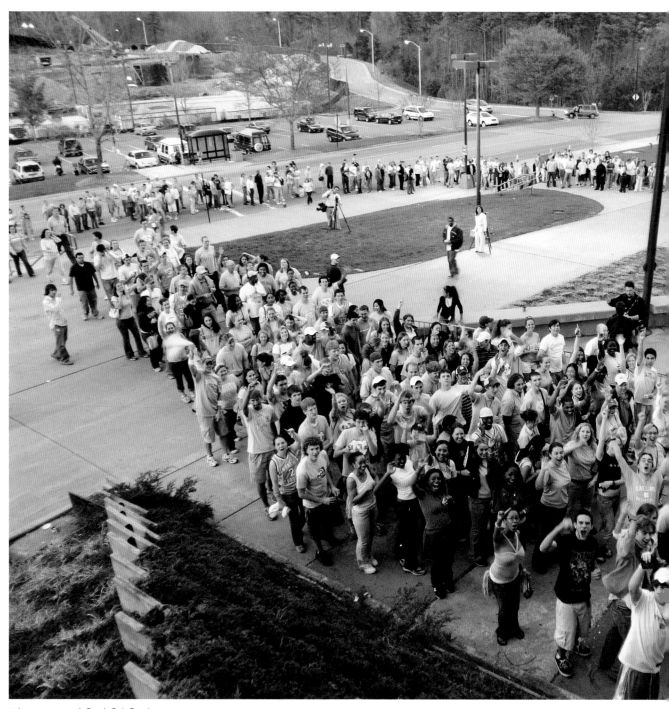

*The Tar Heel faithful flock
to the Chapel of Hoops.*
Photograph by Justin Smith.

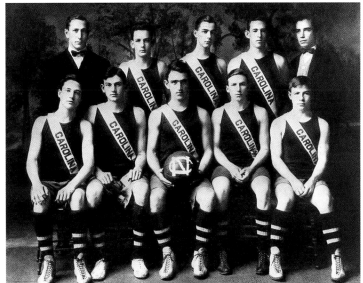

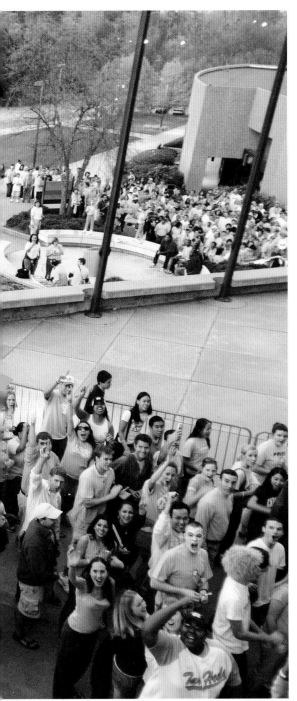

"With the close of the football season of 1913, all eyes are now turned to basketball. It is a sport that is practically new to the university, having been in vogue here for only a few years, but one that is gaining ground." —The Tar Heel, *December 11, 1913.* *Courtesy of the North Carolina Collection, University of North Carolina at Chapel Hill Library.*

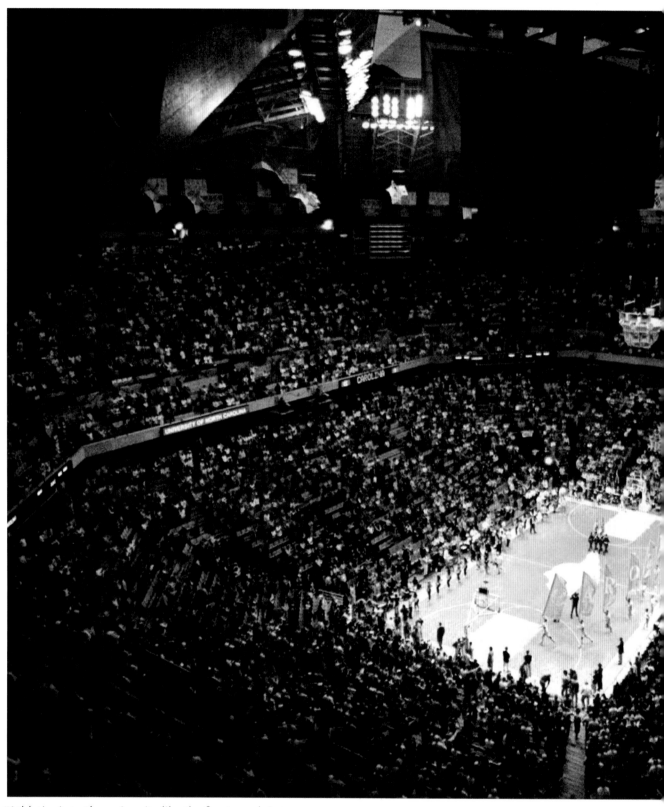

*"Athletics is to the university like the front porch is to
a home. It is the most visible part, yet certainly not the
most important." —Dean Smith.*
Photograph by Dan Sears.

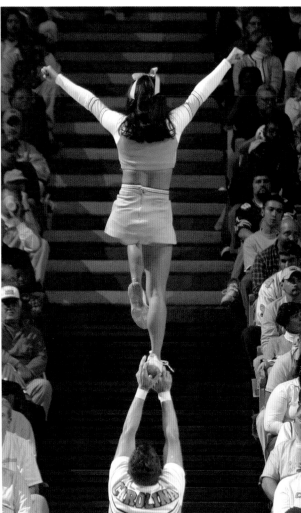

Smith Center cheerleaders.

Photograph by Carolyn Hack.

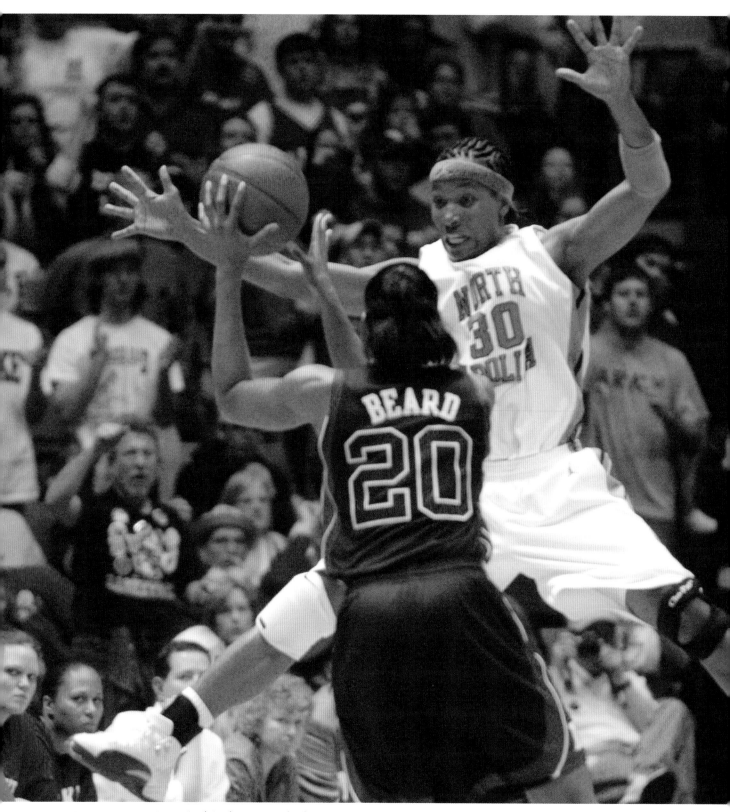

In every sport, ACC rivalries bring out the best in
Carolina's athletes, and women's basketball is no exception.
Photograph by Samkit Shah.

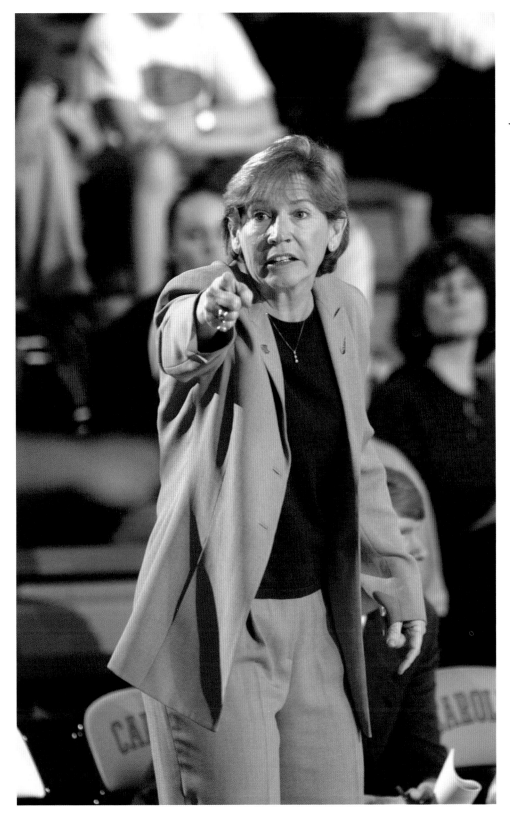

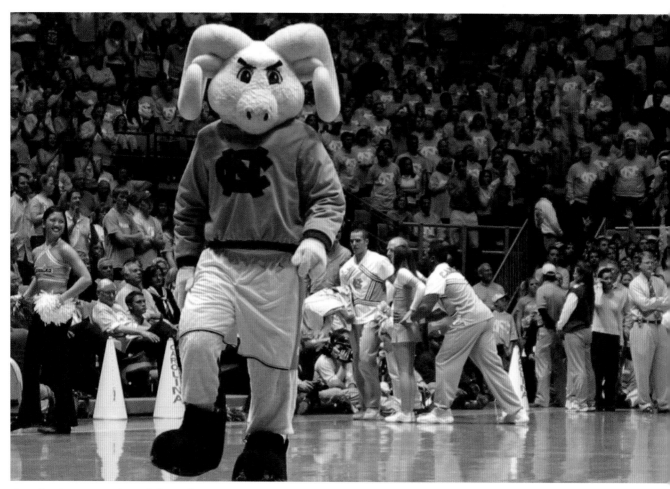

Carolina's own version of the "Blues Brothers" entertains the crowd during a break in the action at the Smith Center.

Photograph by Kim Rowland.

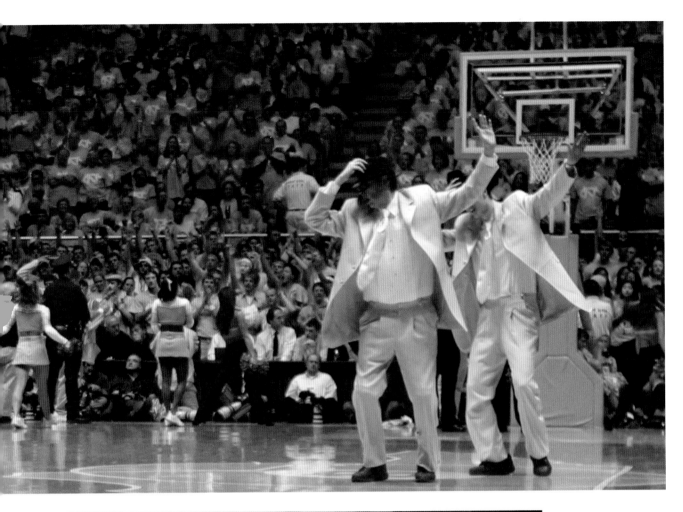

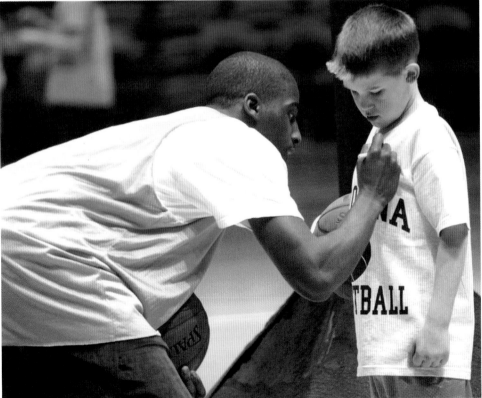

Community outreach—Tar Heel style.
Photograph by Josh Greer.

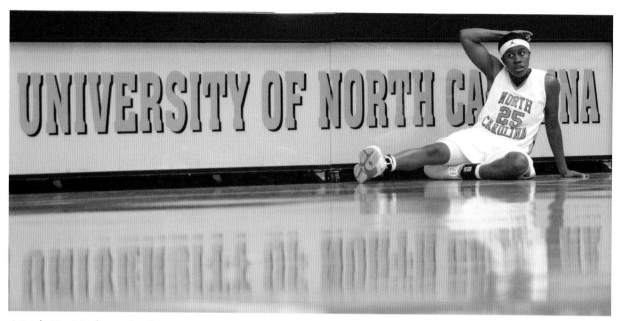

*A Lady Tar Heel watches her
teammates crush the opposition.*
Photograph by Josh Greer.

The one and only No. 23.
Photograph by Bob Donnan.

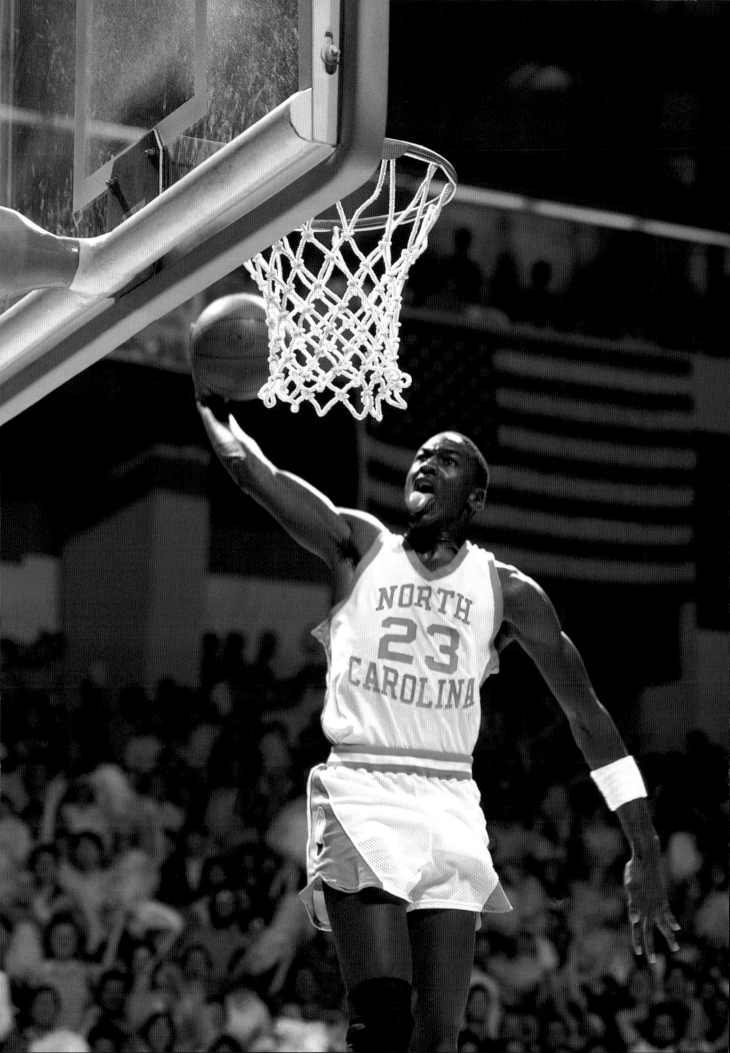

His Airness maintains a presence on campus that is as strong as ever.
Photograph by Carolyn Hack.

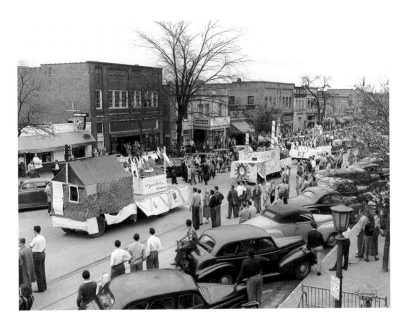

Beat Duke Parade in 1942. Courtesy of the North Carolina Collection, University of North Carolina at Chapel Hill Library.

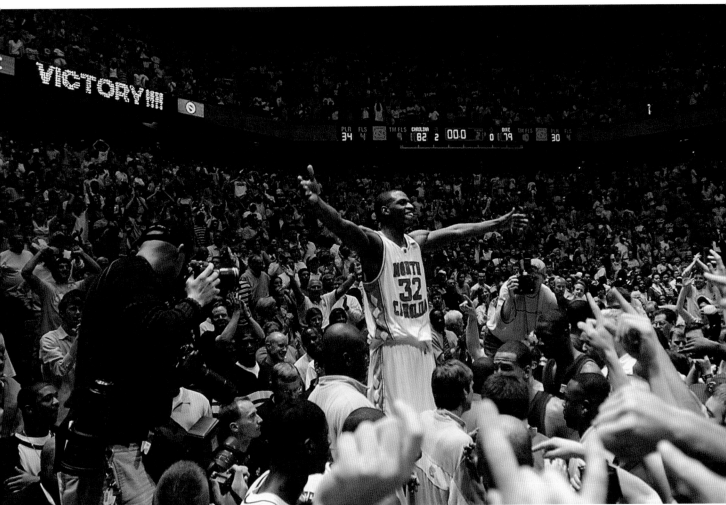

Carolina wins. Duke loses. Life's good.
Photograph by Christopher A. Record / The Charlotte Observer.

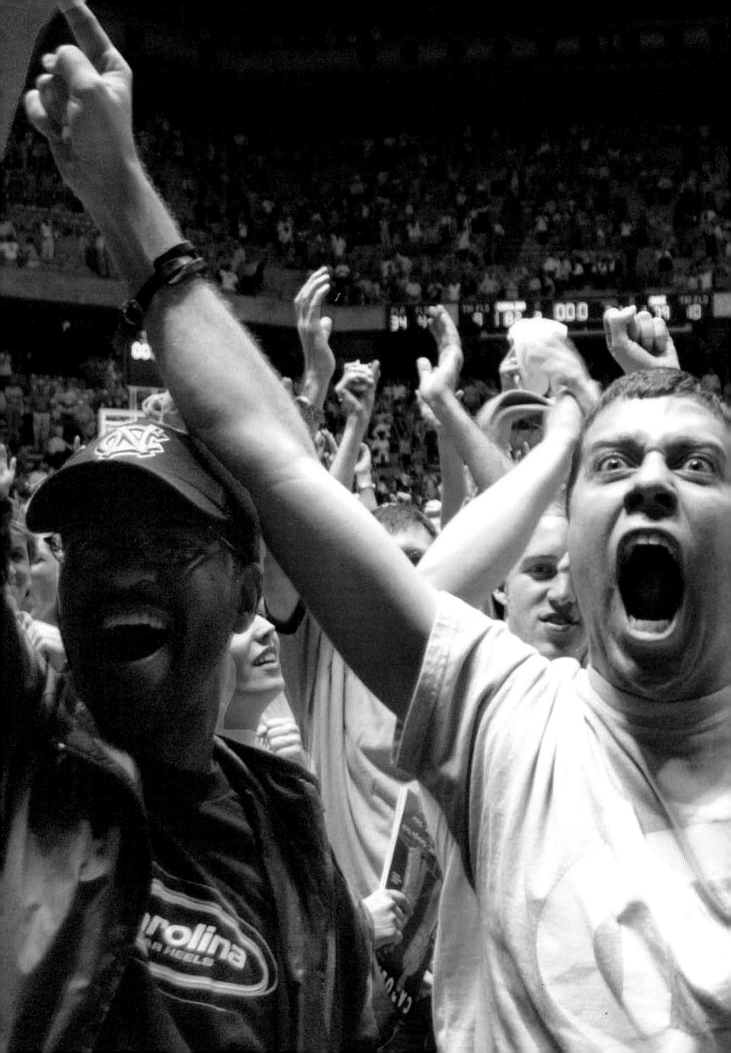

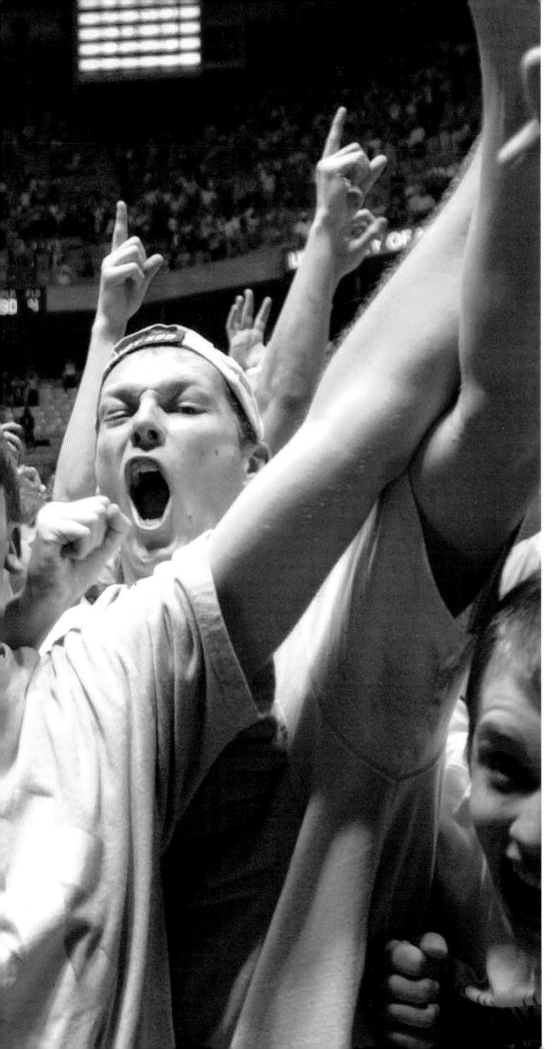

Sedate, quiet, and shy: the quintessential Tar Heel fan. *Photograph by Josh Greer.*

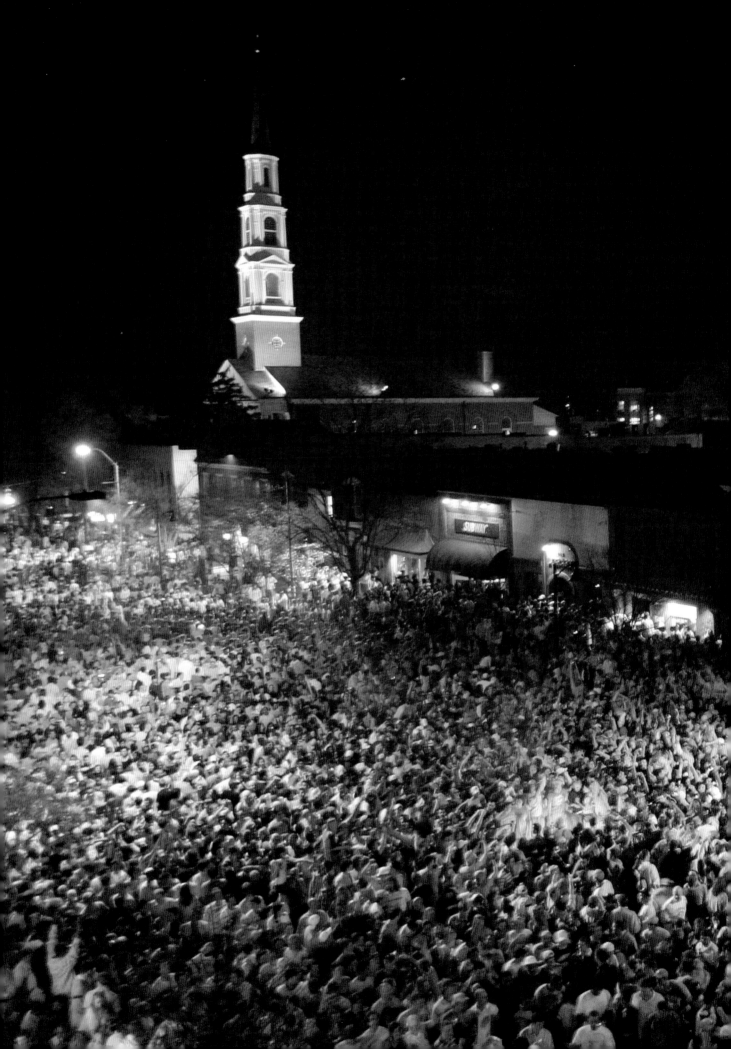

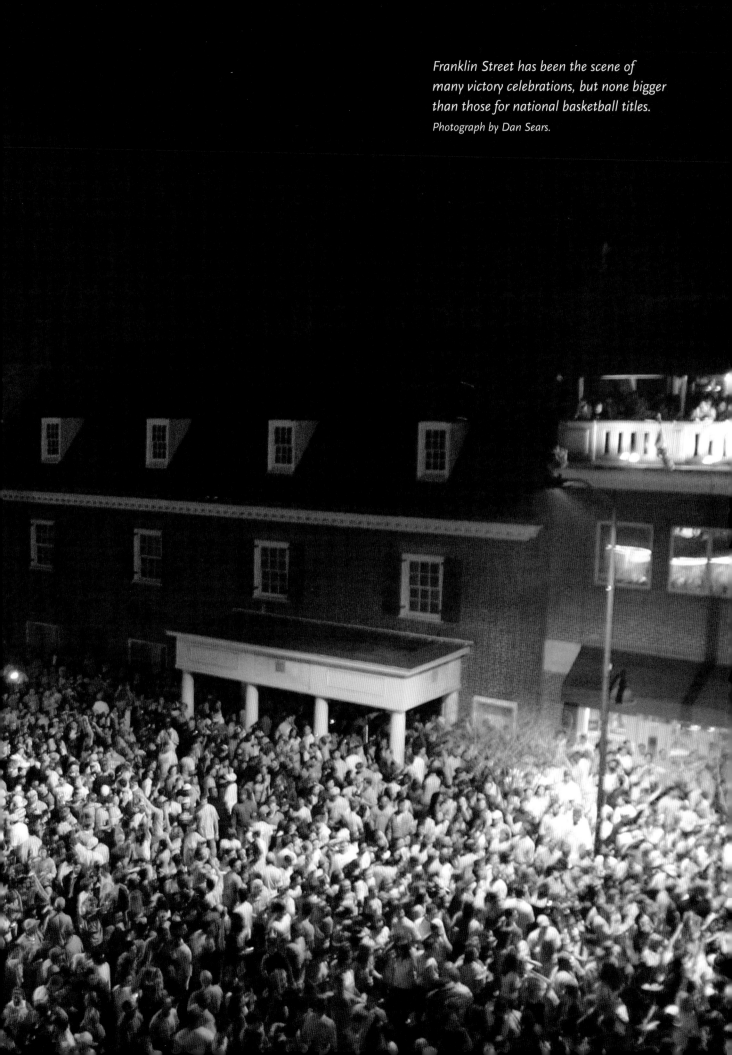

Franklin Street has been the scene of many victory celebrations, but none bigger than those for national basketball titles.
Photograph by Dan Sears.

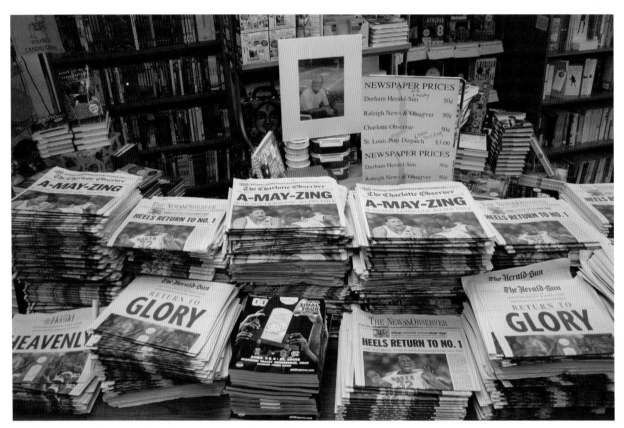

April 5, 2005—just another day on campus? Hardly.

Photograph by Dawn Colclough.

Once teacher and student, always teacher and student, but now Dean Smith and Roy Williams will always be equals as coaches of the NCAA national champions in men's basketball.

Photograph by Jeffrey Camarati.

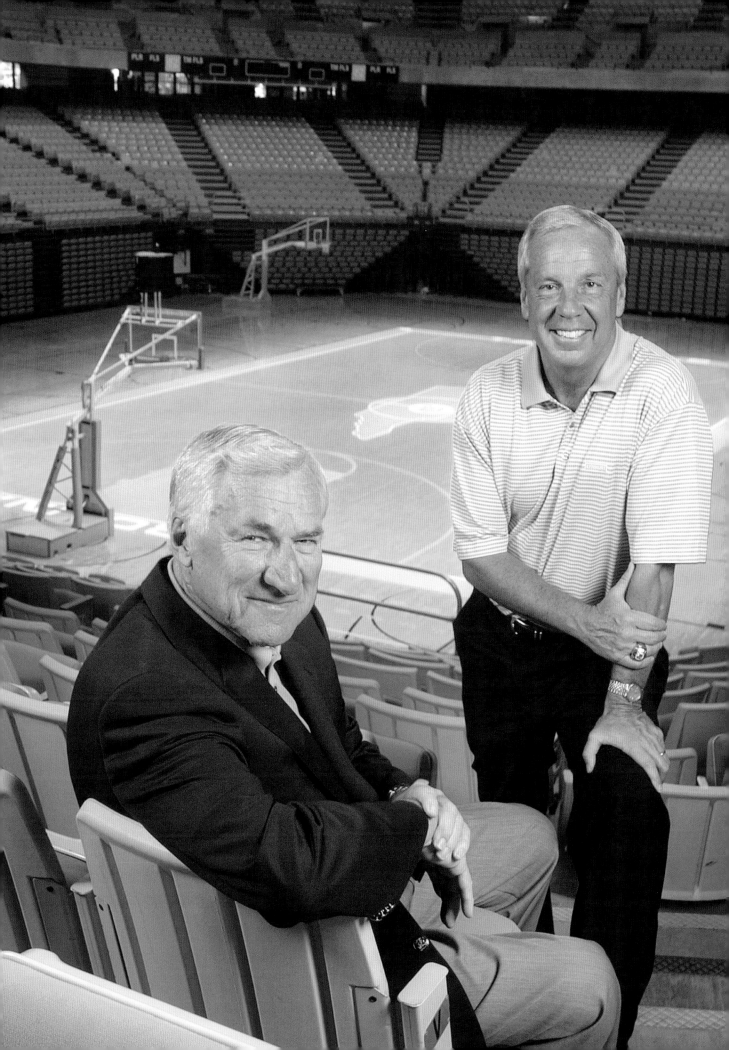

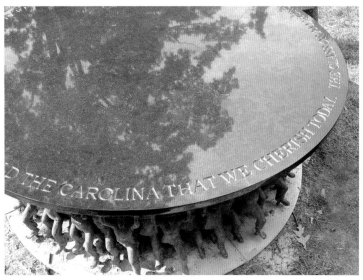

The Unsung Founders Memorial, designed by
artist Do-Ho Suh and given to the university as
a gift from the senior class of 2002, was erected
in 2005. Its inscription reads: "The class of 2002
honors the university's unsung founders—the people
of color, bond and free, who helped build the
Carolina that we cherish today."

Photograph by Gary Simpson.

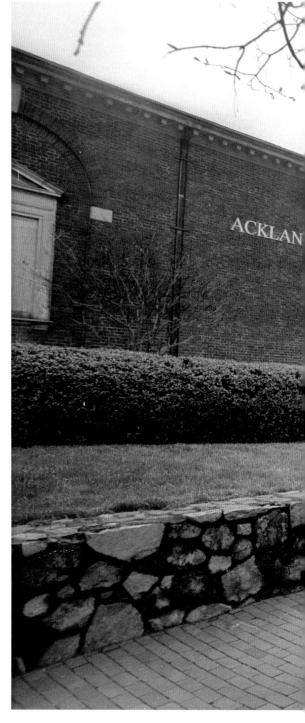

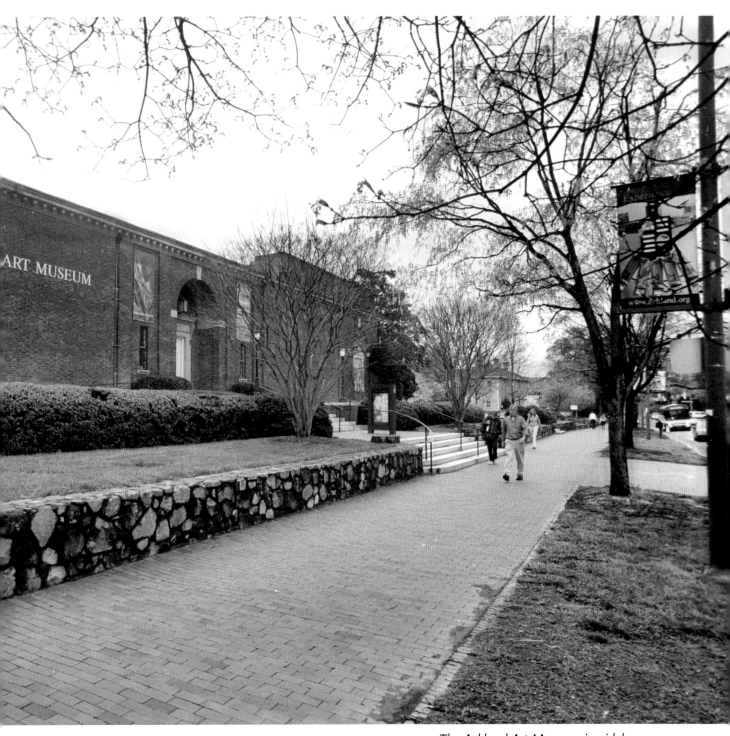

The Ackland Art Museum is widely known for its important collection of Asian, African, European, and American art. Photograph by Hugh Morton.

*A hallway in the Hanes Art Center gives
students an eyeful on their way to class.*
Photograph by Jason Smith.

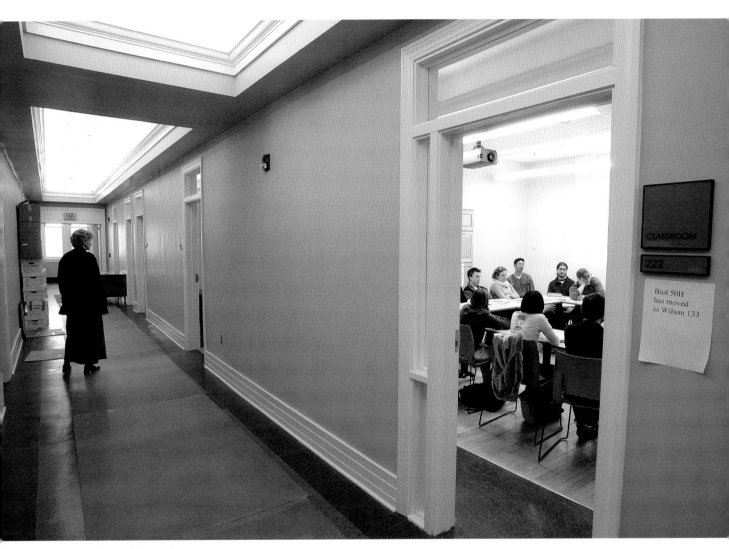

Murphy Building classroom.

Photograph by Dan Sears.

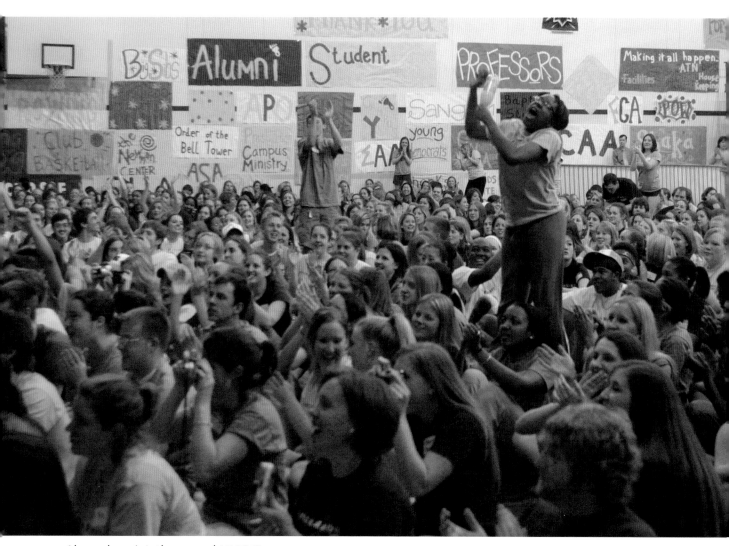

*Always hoppin', the annual UNC Dance
Marathon raises money for the North Carolina
Children's Hospital.*

Photograph by Gabi Trapenberg.

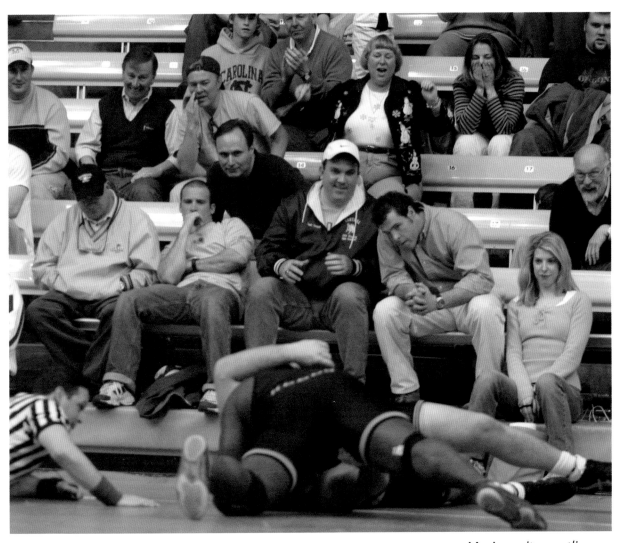

Men's varsity wrestling.
Photograph by Gabi Trapenberg.

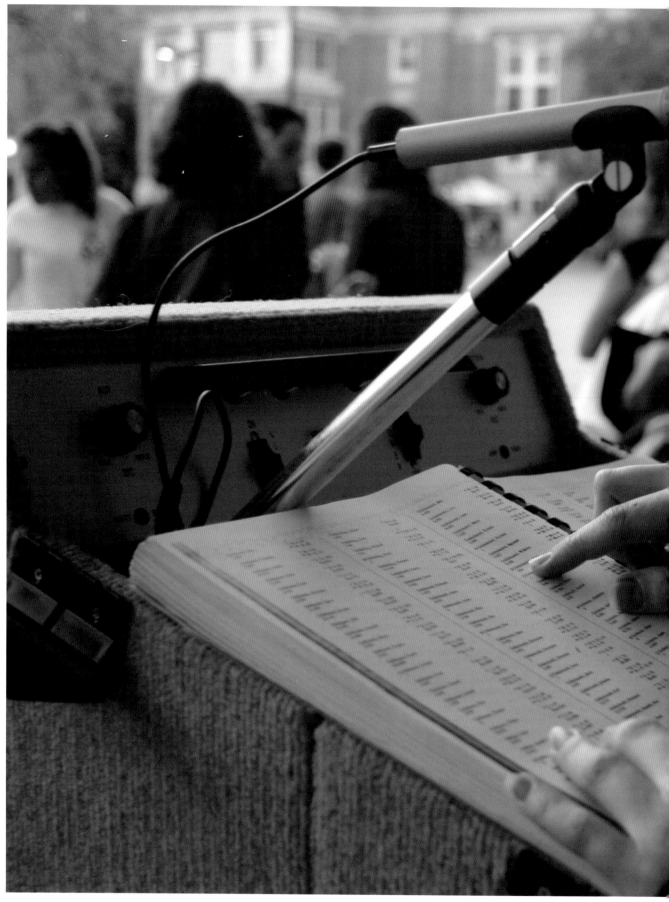

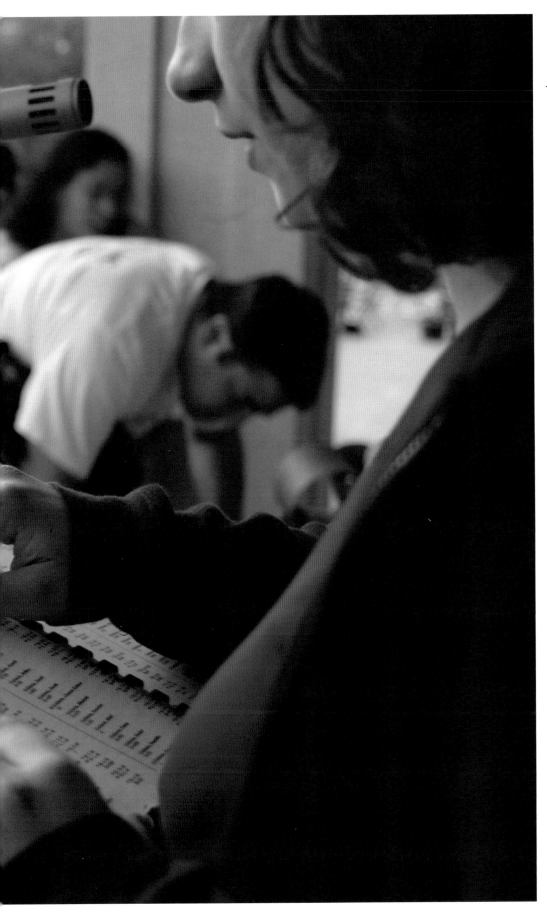

The annual Reading of the Names for Holocaust Remembrance Week.
Photograph by Kim Rowland.

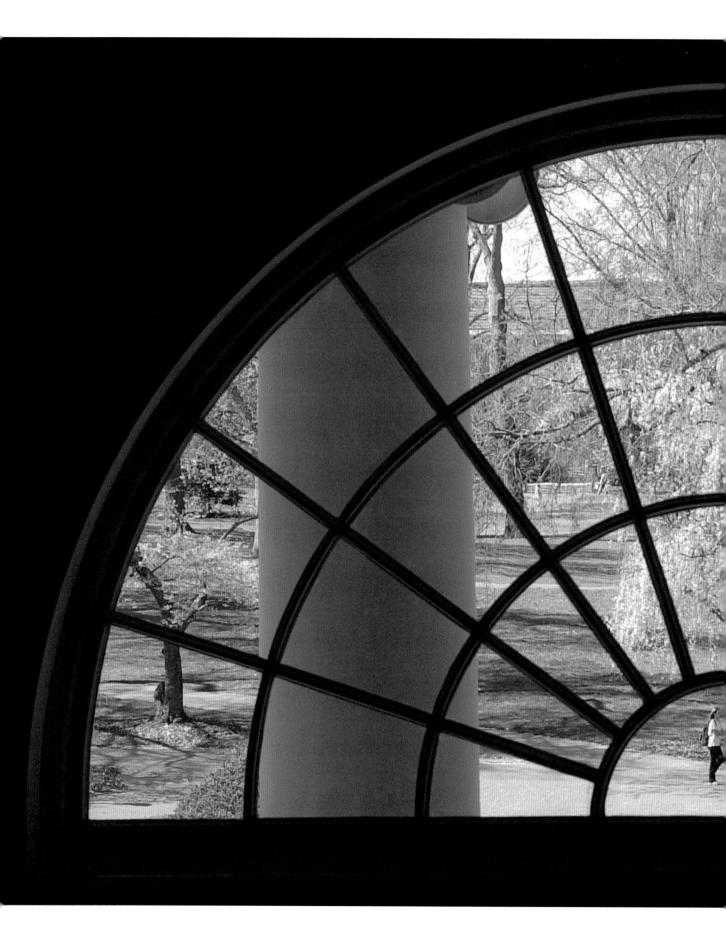

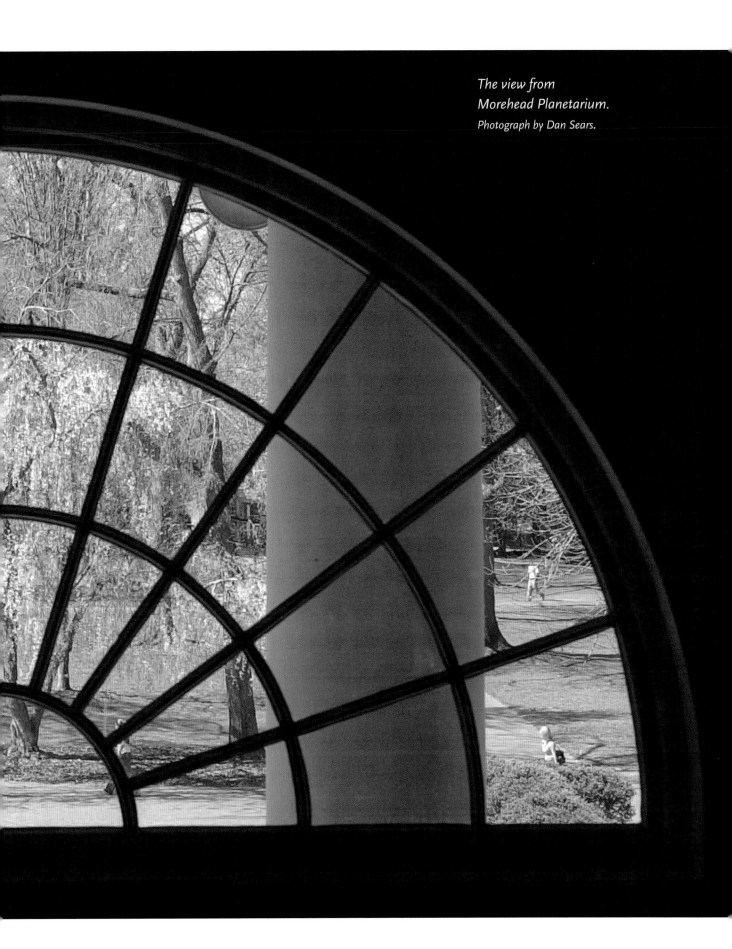

The view from
Morehead Planetarium.
Photograph by Dan Sears.

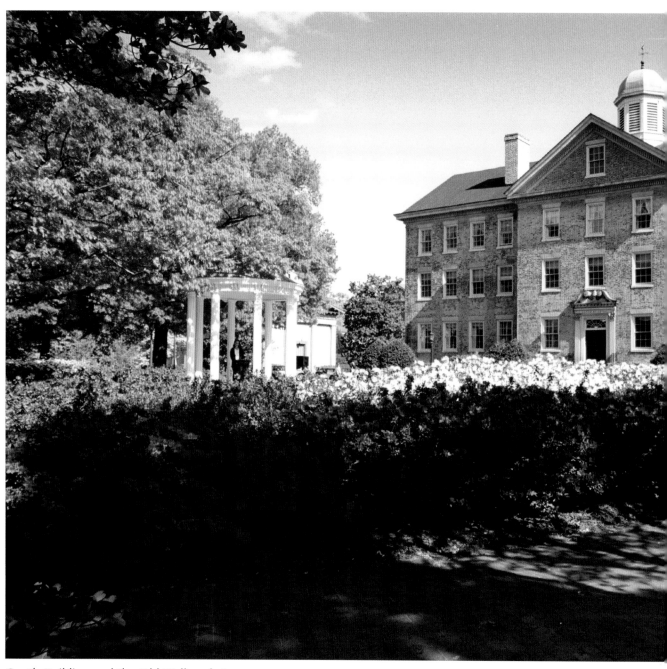

*South Building and the Old Well at their
most iconic, with the azaleas of spring.*

Photograph by Stacy Marsh.

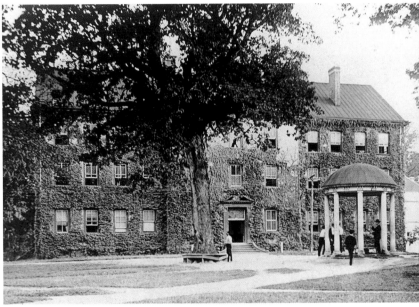

The Old Well and South Building as they looked in 1907.
Courtesy of the North Carolina Collection, University of North Carolina
at Chapel Hill Library.

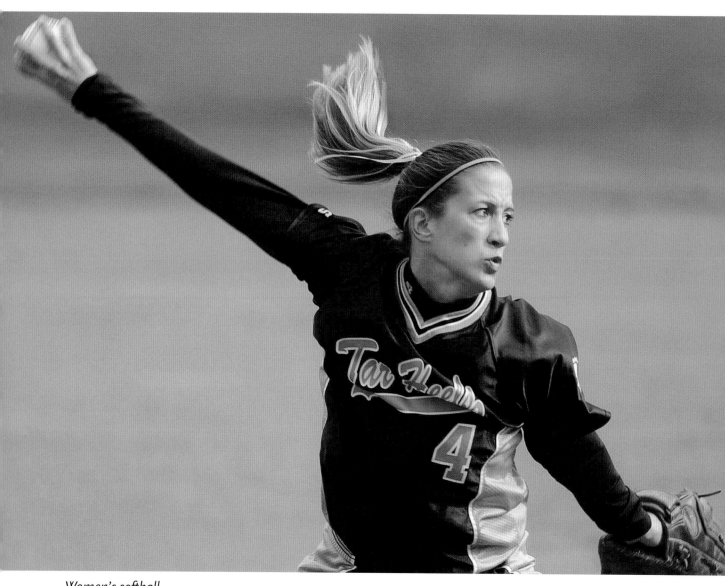

Women's softball.
Photograph by Jeffrey Camarati.

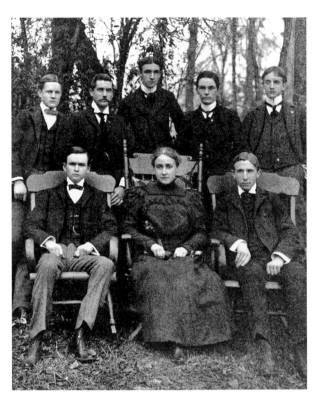

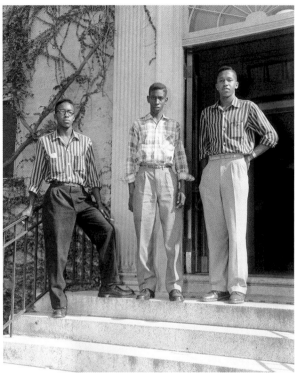

Mary S. McRae, the first woman to register at UNC, with other members of the Tar Heel *staff in 1898.*
Courtesy of the North Carolina Collection, University of North Carolina at Chapel Hill Library.

Leroy Frasier, John Lewis Brandon, and Ralph Frasier, the first African American students at UNC-Chapel Hill, stand on the steps of South Building after registering for classes in September 1955. Courtesy of the North Carolina Collection, University of North Carolina at Chapel Hill Library.

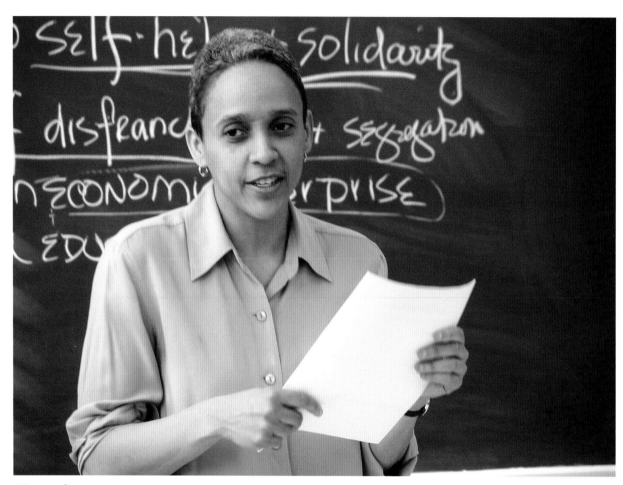

History class.

Photograph by Kyle York.

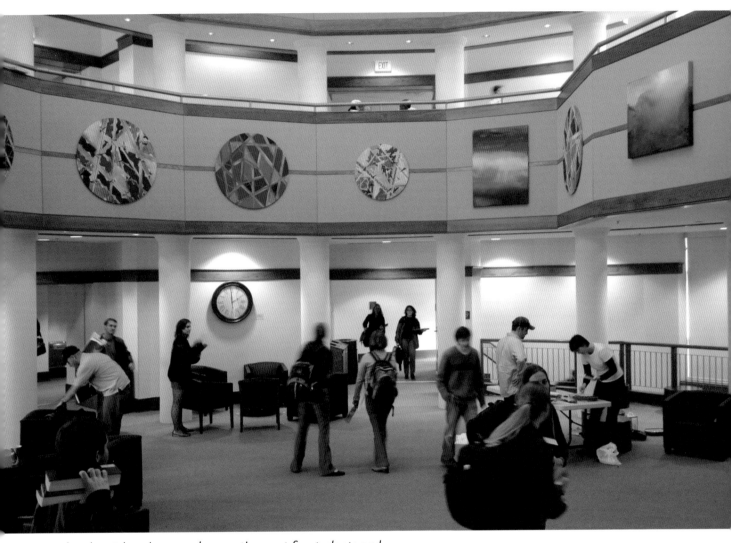

*An airy atrium is a popular meeting spot for students and
faculty in Van Hecke–Wettach Hall, home to the School of Law.*

Photograph by John Jones.

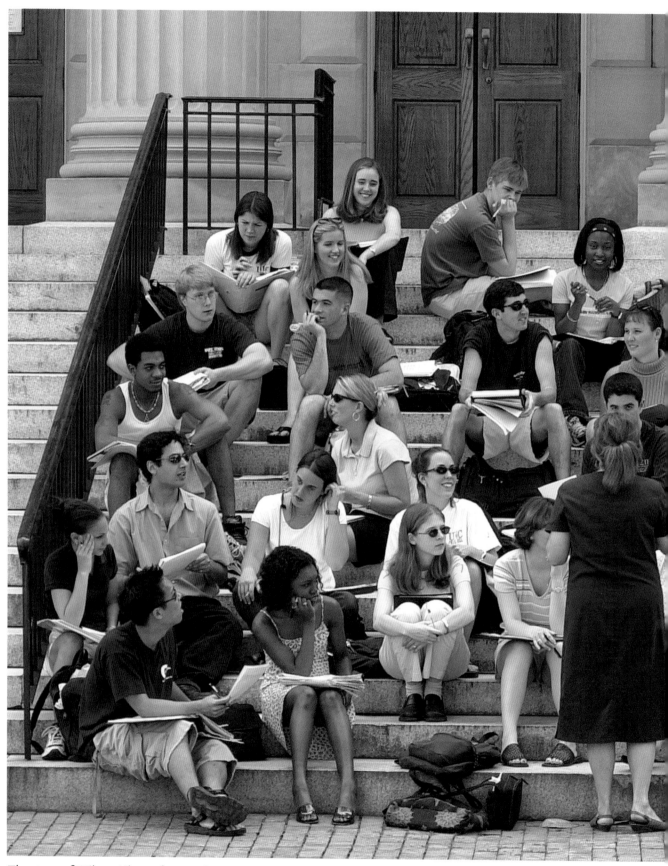

The steps of Wilson Library frequently serve as an impromptu classroom.

Photograph by Dan Sears.

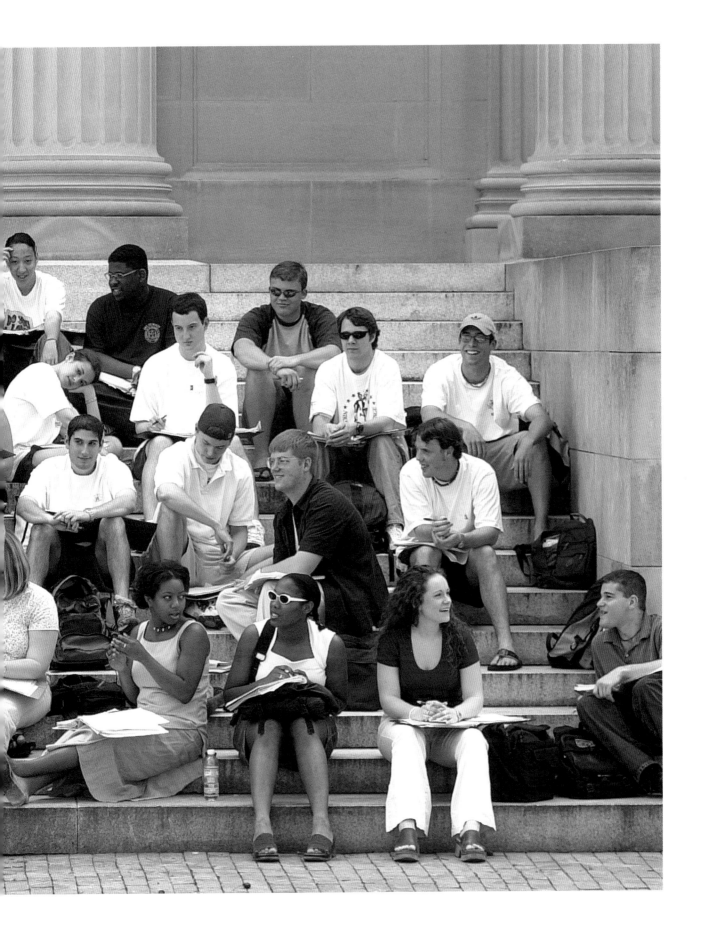

South Building, architectural detail.
Photograph by Dan Sears.

*A winding staircase
in the McColl Building.*
Photograph by Dan Sears.

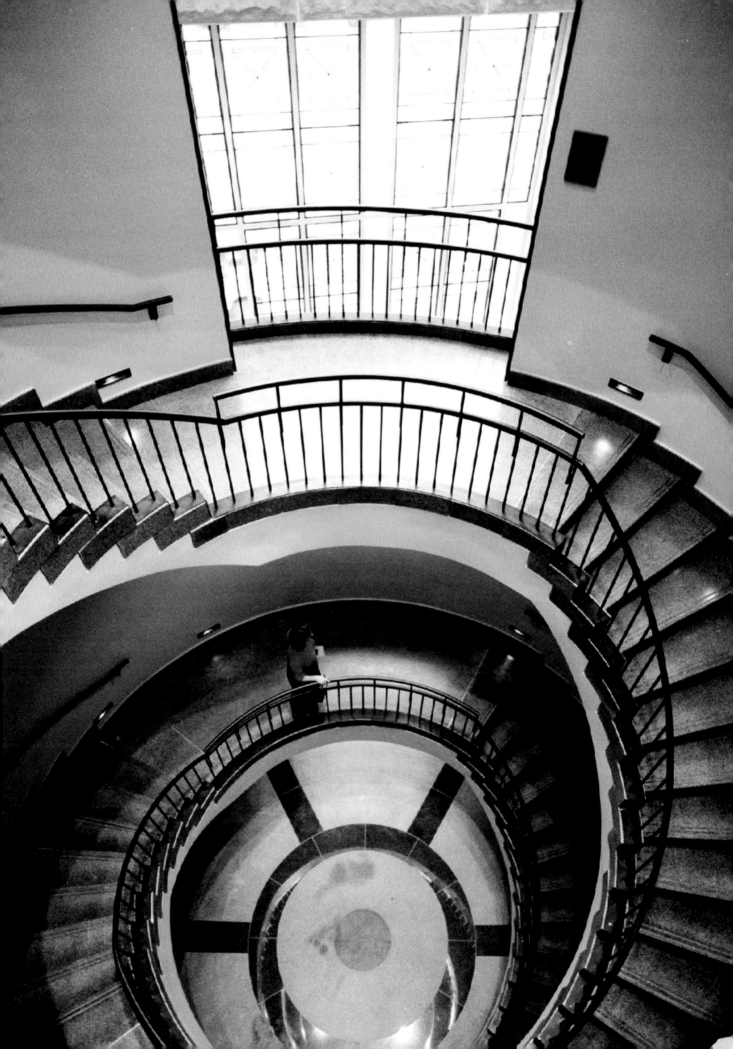

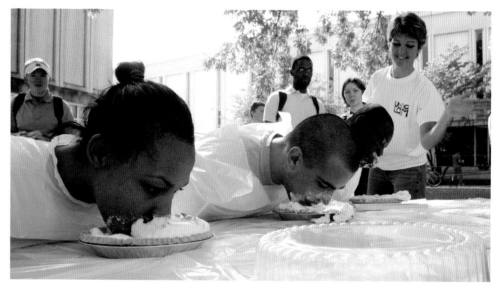

The pie-eating contest: a time-honored, in-your-face Pit activity.
Photograph by Justin Smith.

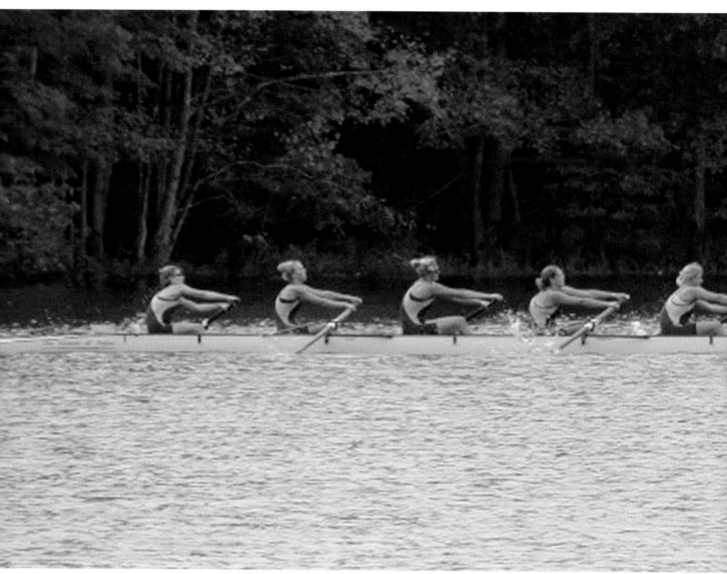

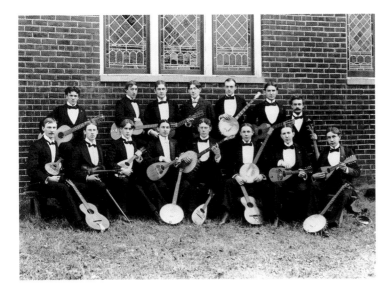

Music Club, 1896.
Courtesy of the North Carolina Collection,
University of North Carolina at Chapel Hill
Library.

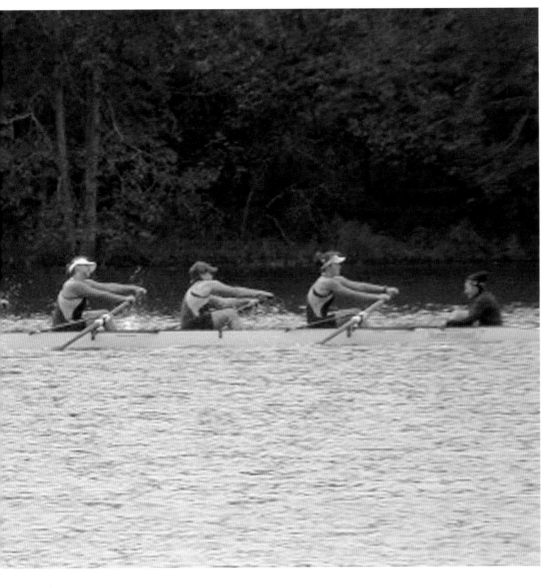

Carolina's
varsity women's
crew team breaks
the stillness at
University Lake.
Photograph by
Julia Domina.

Lecture in Gerrard Hall.
Photograph by Samkit Shah.

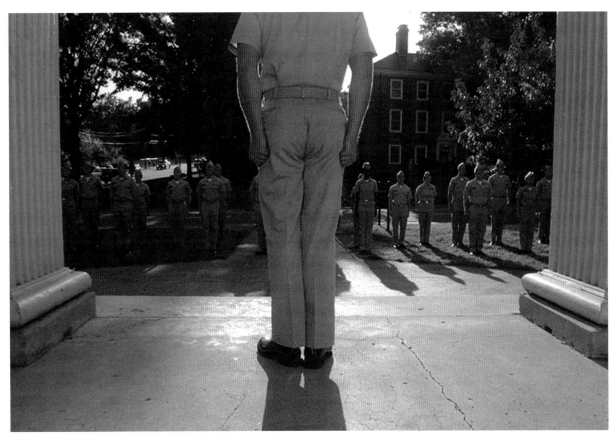

*View from the steps of the
Naval Armory, home of Carolina's
ROTC program.*
Photograph by Justin Cook.

Every campus has a low-tech way of getting the word out. The cubes do the trick at Carolina.

Photograph by Ashley Pitt.

Photograph by Kim Rowland.

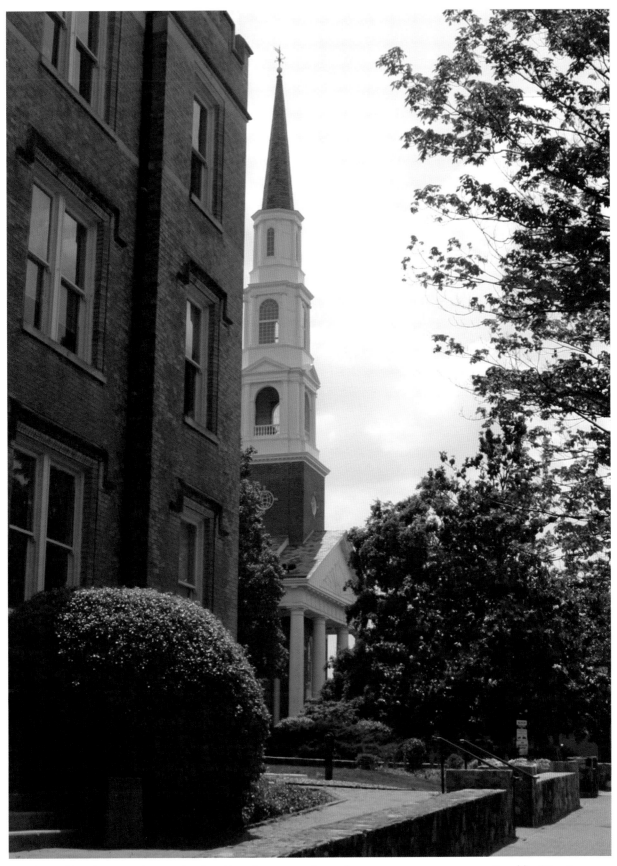

Battle Hall and University Methodist Church, as seen from the entrance to campus on Franklin Street.
Photograph by Sandy Greene.

Franklin Street's flower ladies and street musicians add to the character of Chapel Hill as a quintessential university town.
Courtesy of the Daily Tar Heel.

The Ram's Head Rathskeller, truly a Chapel Hill institution, lures students with such delights as a dish of lasagne popularly known as the "bowl of cheese."
Photograph by Dawn Colclough.

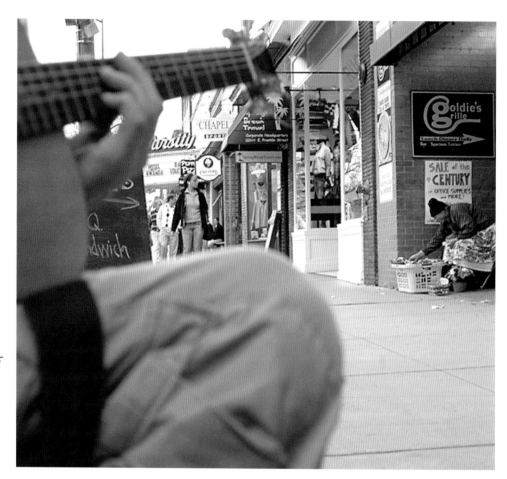

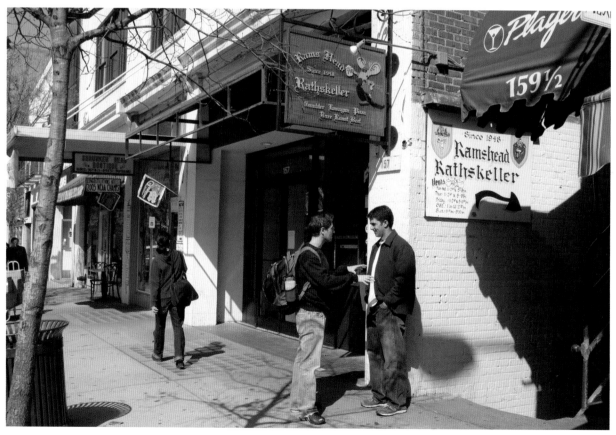

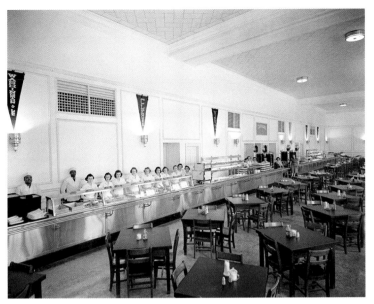

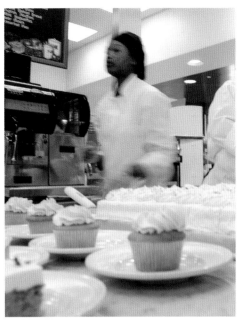

For years, Lenoir Dining Hall has been every student's four-square destination. *Photograph by Bayard Wootten, courtesy of the North Carolina Collection, University of North Carolina at Chapel Hill Library.*

If God is not a Tar Heel, why are these cupcakes Carolina blue?
Photograph by Justin Smith.

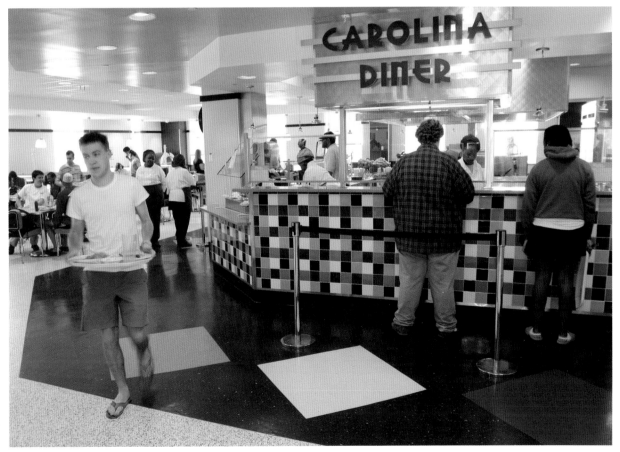

The new Ramshead Center, built just south of the George Watts Hill Alumni Center and near Kenan Stadium, links North and South Campuses, with dining halls, a parking deck, and much-needed space for tailgate picnics in the fall. *Photograph by Justin Smith.*

A drink from the Old Well guarantees academic success. But be warned: students must take a drink each semester; once is not enough.

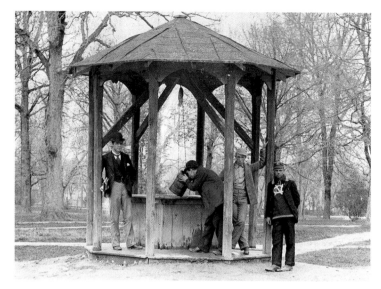

Courtesy of the North Carolina Collection, University of North Carolina at Chapel Hill Library

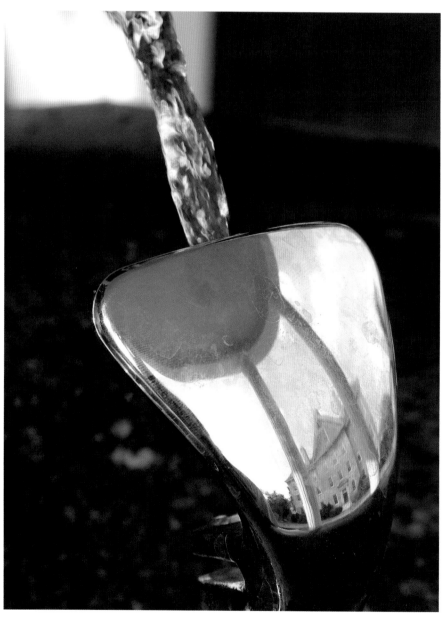

Photograph by Gary Simpson.

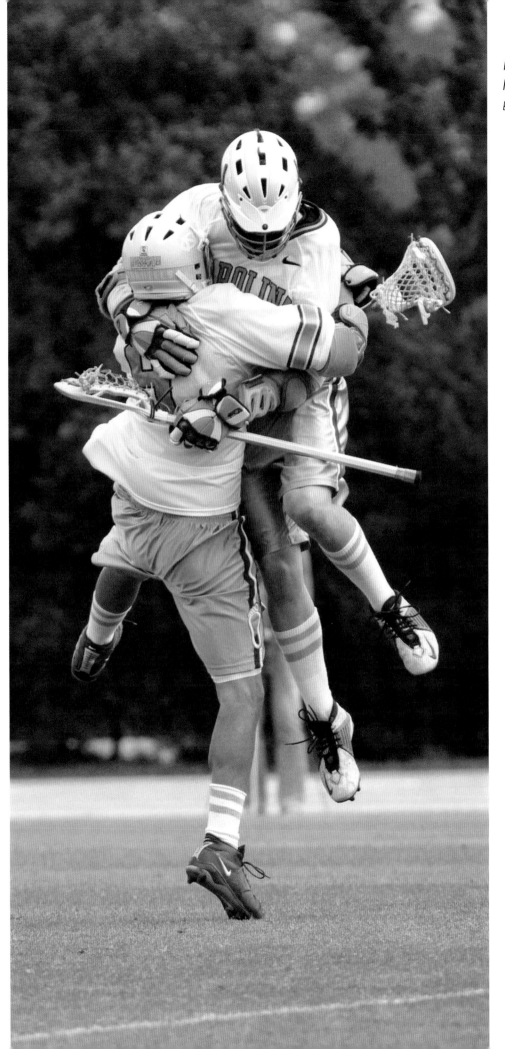

*Men's varsity
lacrosse.* Photograph
by Samkit Shah.

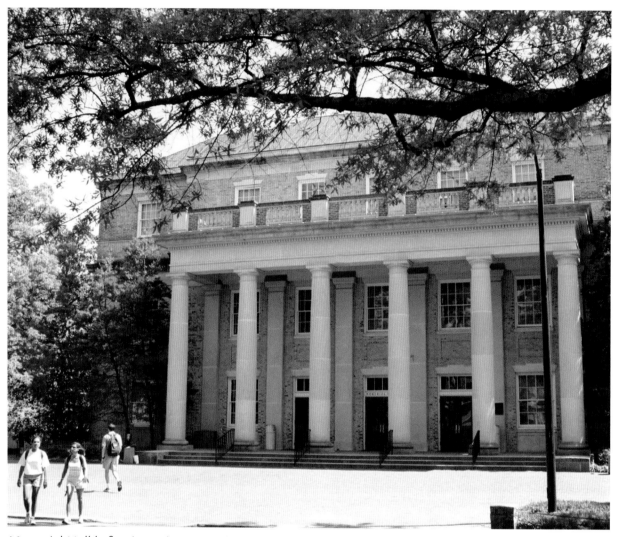

Memorial Hall before its major renovation.

Photograph by Dan Sears.

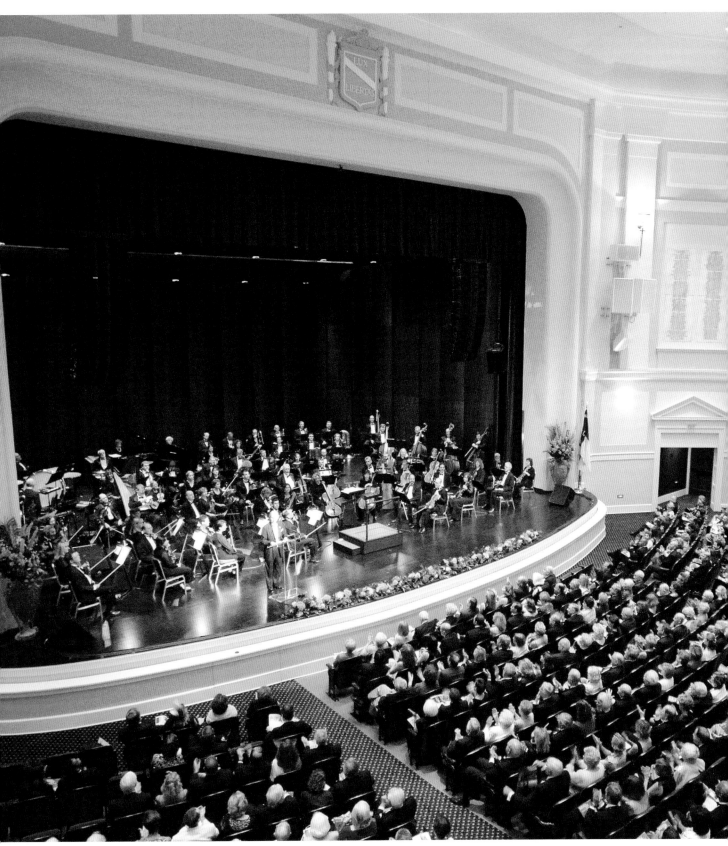

Always a star-magnet, Memorial Hall underwent a major renovation and reopened in 2005. Still gorgeous, now air-conditioned and acoustically perfect, Memorial extends its embrace to the whole community of Chapel Hill, which flocks there to hear symphonies, musicals, and speakers. Photograph by Dan Sears.

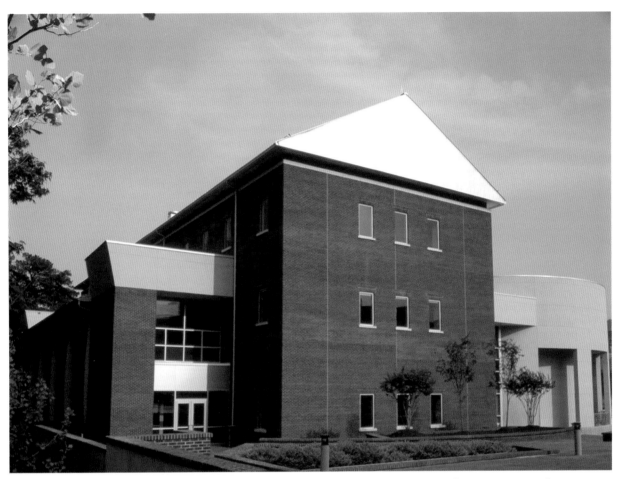

Since 1988, the Stone Center has served as one of the preeminent sites in the nation for the critical examination of African and African American Diaspora cultures. Photograph by Dan Sears.

The Sonja Haynes Stone Center for Black Culture and History. Photograph by Dan Sears, courtesy of the Carolina Alumni Review.

*Varsity baseball,
then and now.*

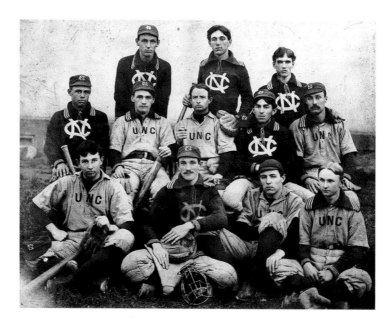

*Courtesy of the North
Carolina Collection,
University of North
Carolina at Chapel Hill
Library.*

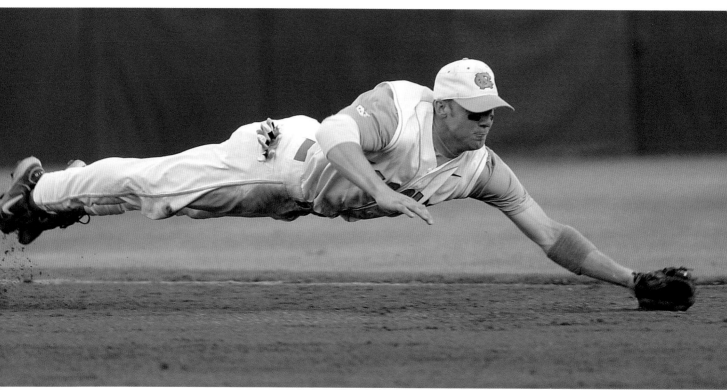

Photograph by Josh Greer.

Fraternities and sororities
often hold social events to
benefit charities.
Photograph by Dawn Colclough.

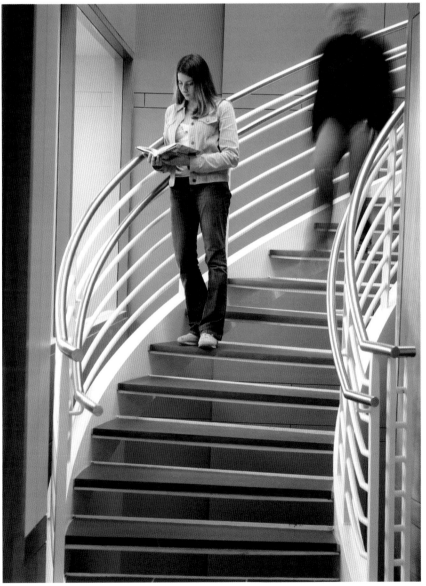

Robert B. House
Undergraduate Library,
a good place to begin to
understand Carolina's rich,
complex library system.
Photograph by Dan Sears.

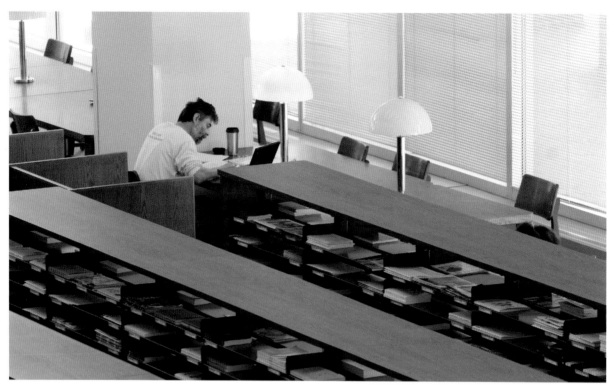

Journals reading room, Davis Library.
Photograph by Justin Smith.

"So far from forgetting the blessed place, I think my picture of it grows clearer every year: it was as close to magic as I've ever been." —Thomas Wolfe.
Photograph by Stacie Smith.

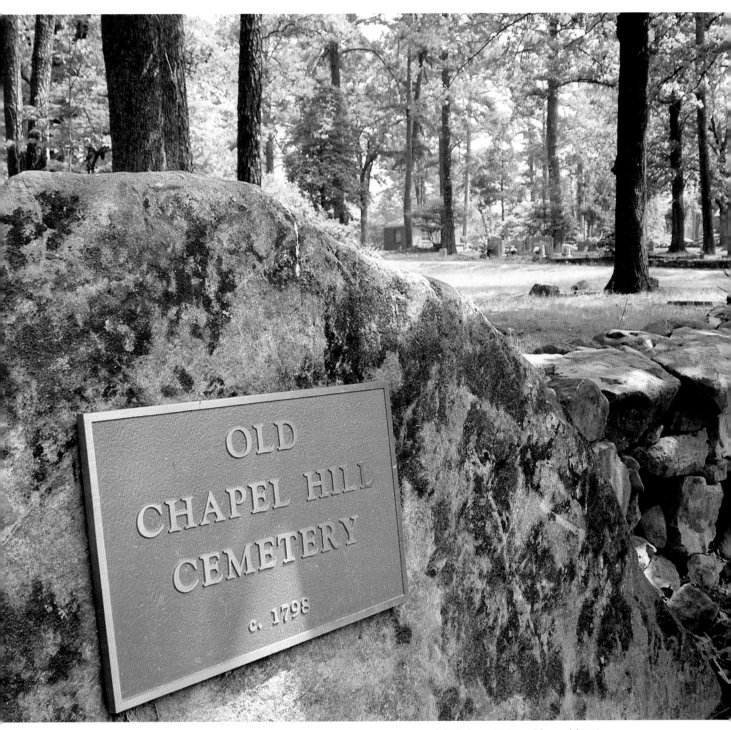

Their inscriptions blurred by time, many of the gravestones in the lovely little cemetery at the heart of campus attest to its age. Here lie many famous professors and alumni, beside the plainly marked graves of African American laborers and servants, some of whom were slaves.
Photograph by Gary Simpson.

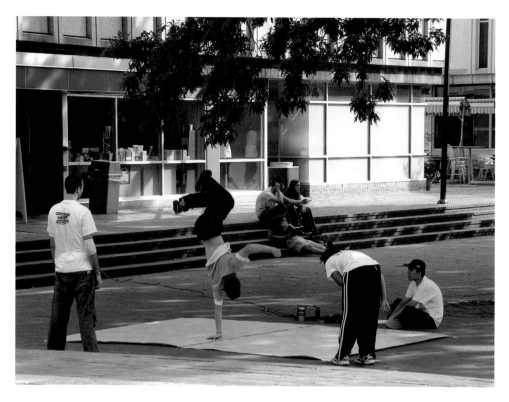

A spring
"break," Pit-style.
Photograph by
Gary Simpson.

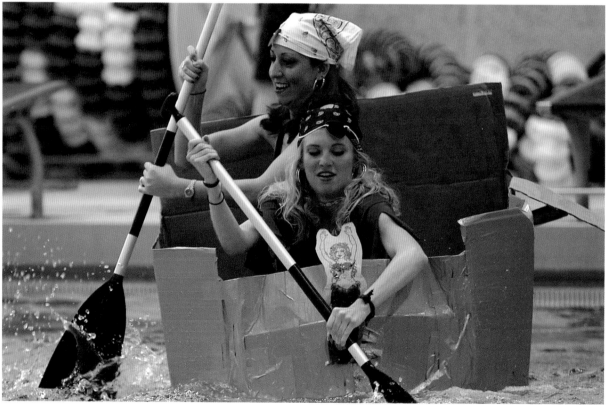

Cardboard boat racers paddle in Koury Natatorium.
Photograph by Josh Greer.

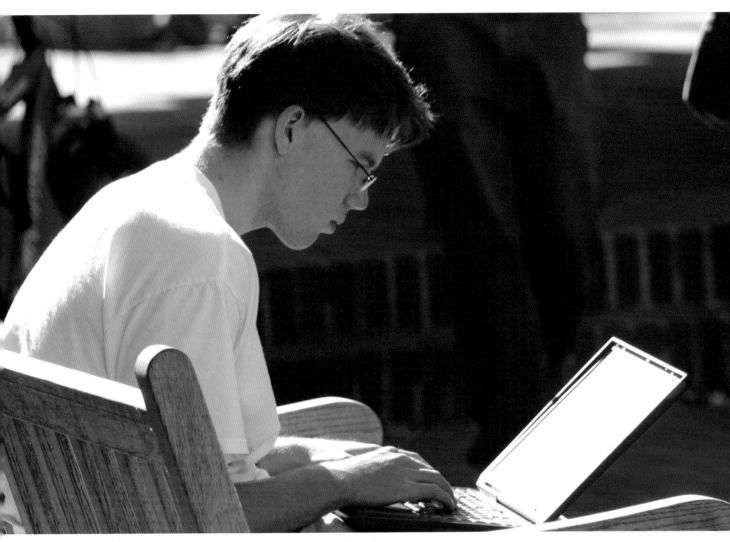

The wireless university: check your e-mail from any bench on campus.
Photograph by Justin Smith.

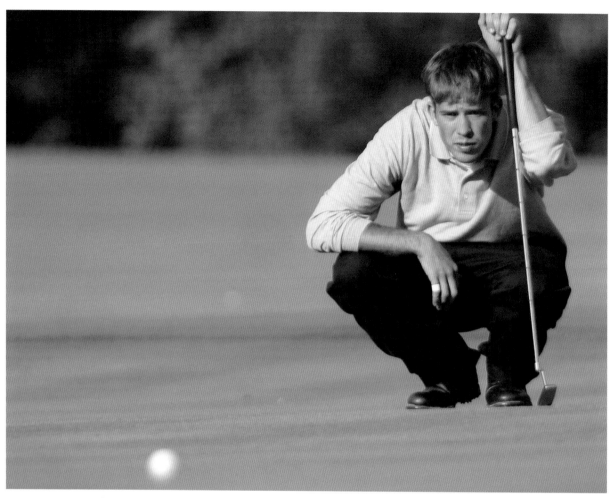

Men's varsity golf.
Photograph by Josh Greer.

Women's varsity tennis.
Photograph by Carolyn Hack.

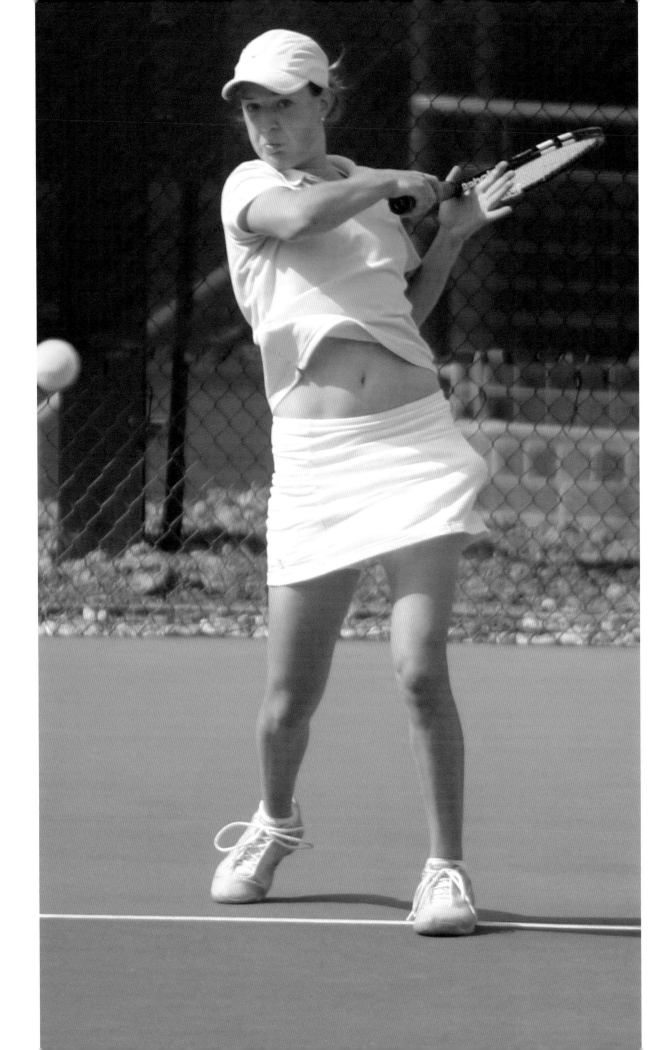

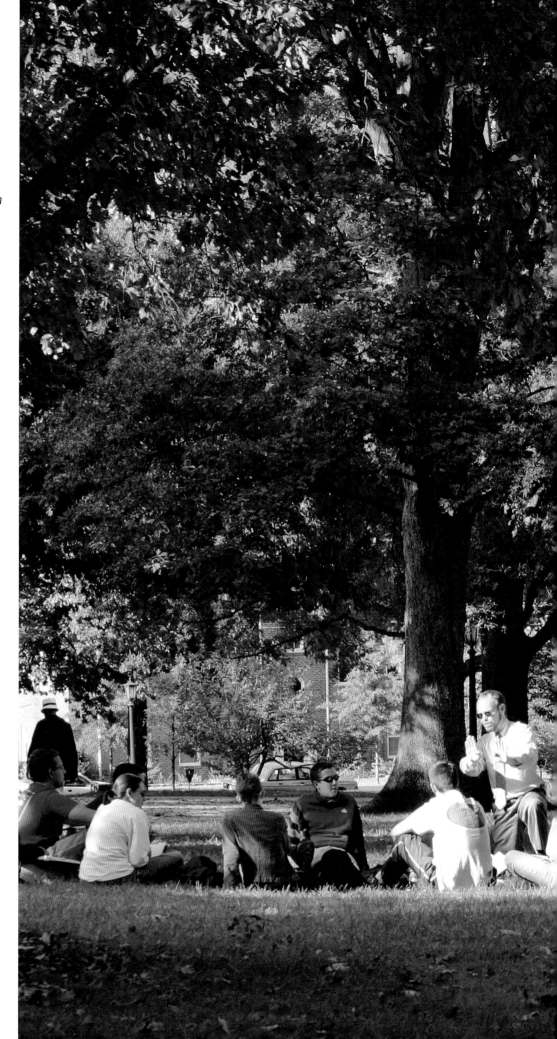

On spring days, it's common to see classes meet on McCorkle Place, near the marble obelisk of the Caldwell Monument. Joseph Caldwell, himself a professor of mathematics and the first president of the university, is buried at the base of the monument, with his wife, Helen.

Photograph by Justin Smith.

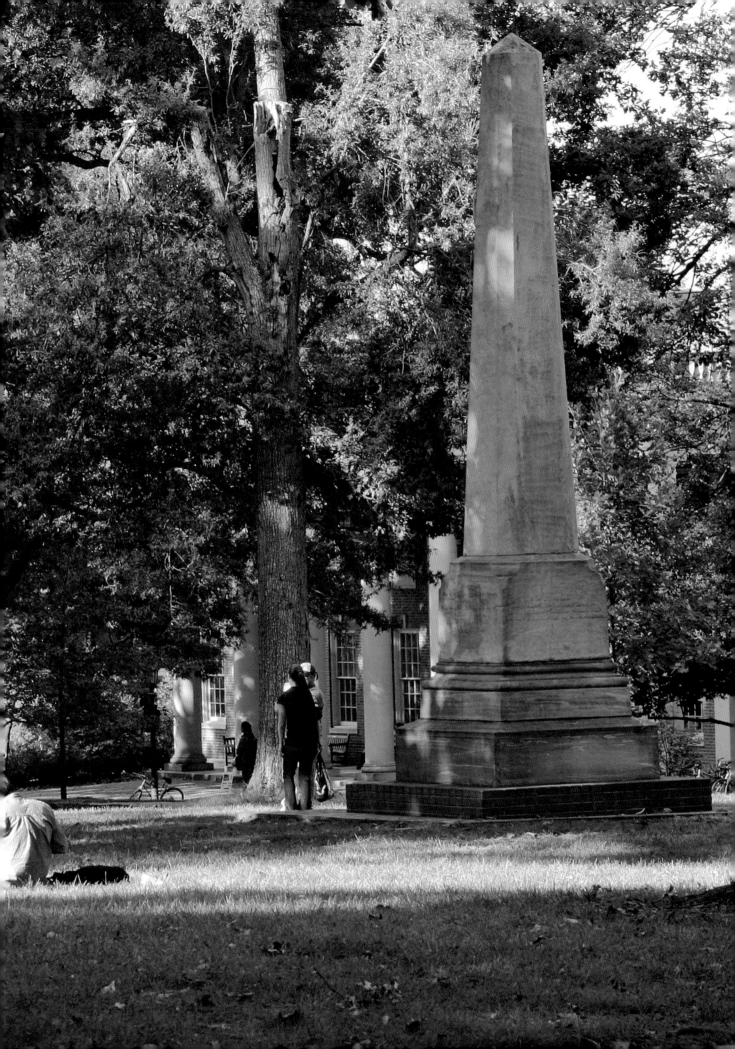

"I believe heaven must be a lot like Chapel Hill in the spring." —W. D. Moss.
Photograph by Dan Sears.

The "ultimate" diversion.
Photograph by Dan Sears.

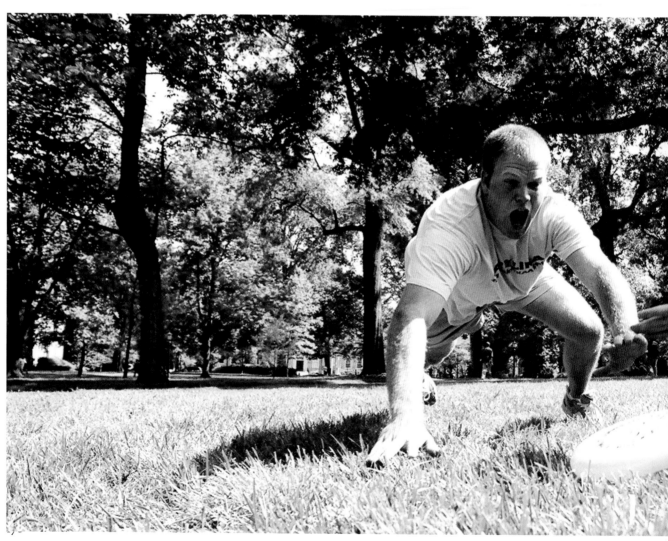

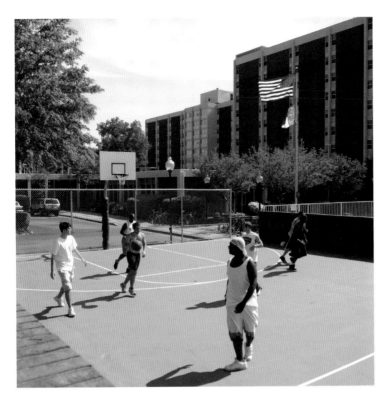

A Granville Towers pickup game.
Photograph by Andrew Synowiez.

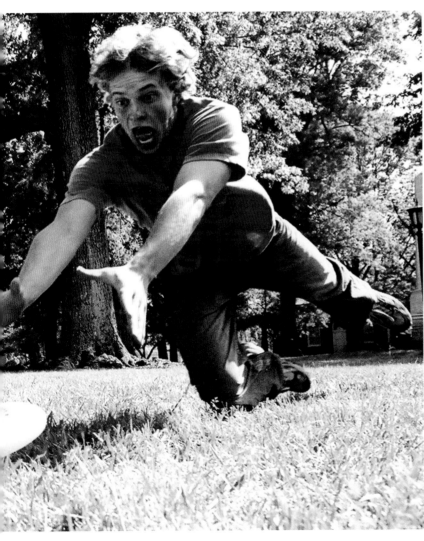

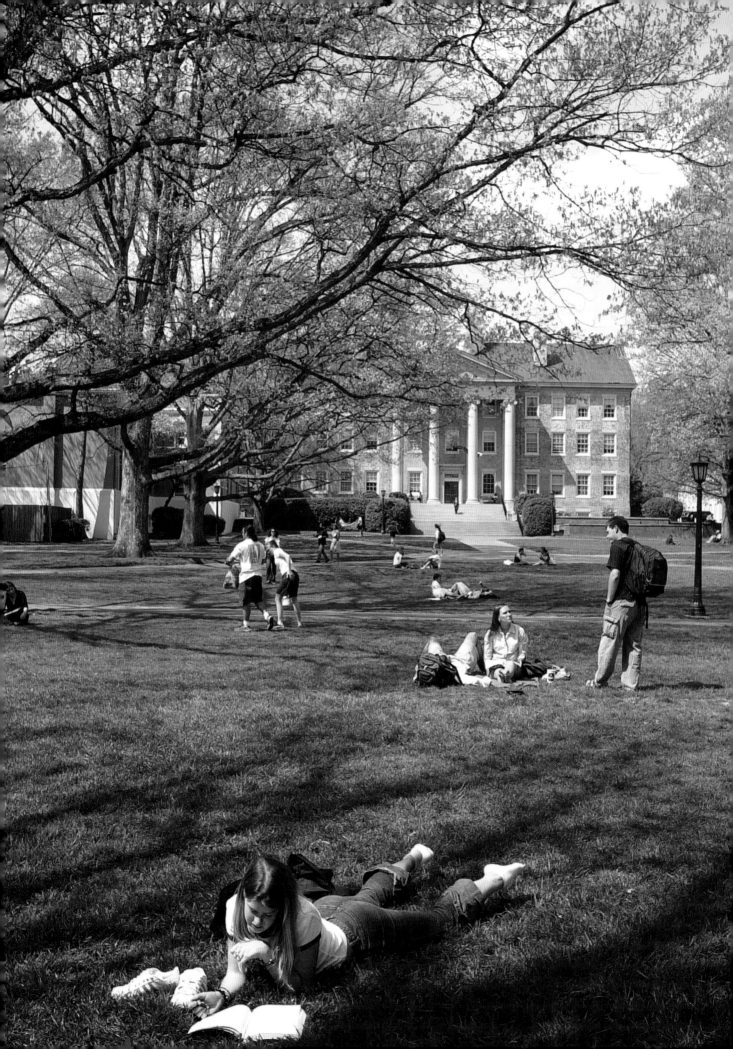

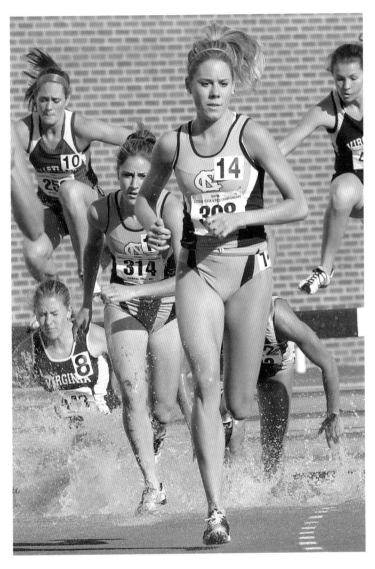

Carolina's highly regarded track and field teams regularly host the ACC championships at the Irwin Belk Track and Fetzer Field.
Photograph by Josh Greer.

Spring comes to Polk Place.
Photograph by Justin Smith.

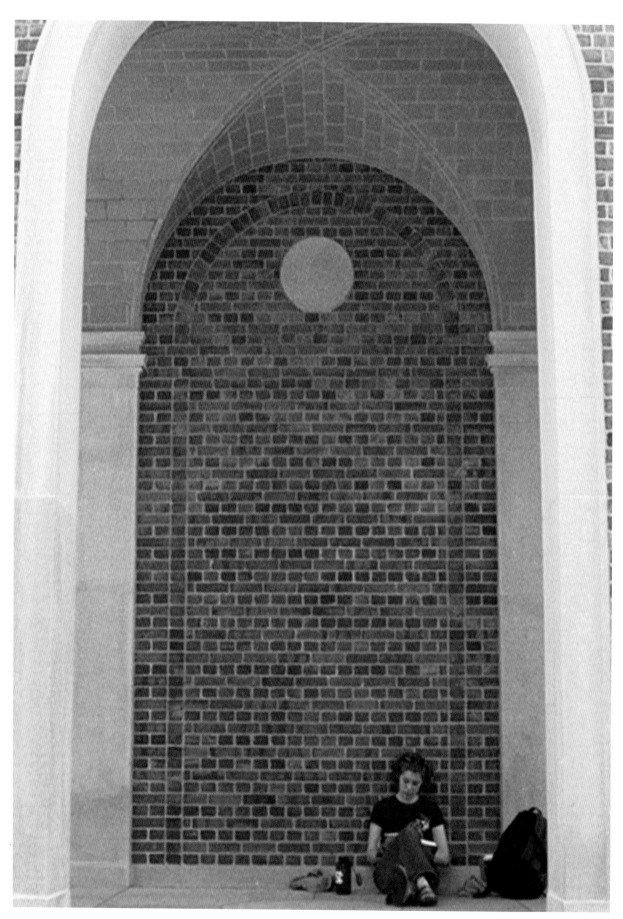

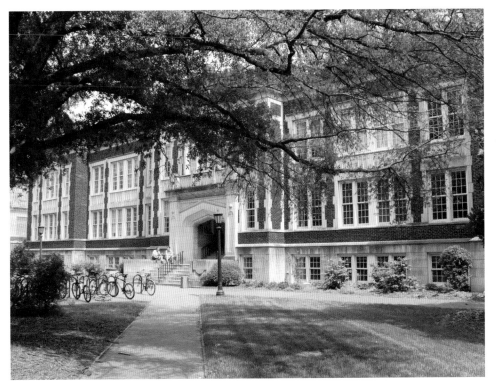

Phillips Hall, the home of math, physics, and engineering classes on campus.
Photograph by Jason Smith.

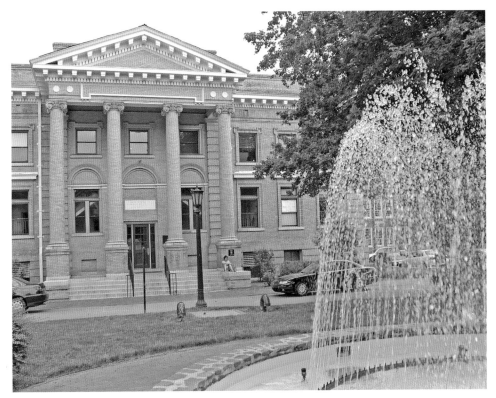

In 1904, when Bynum Hall was built, it served as the campus gymnasium and contained an indoor pool, a track, and showers. In the wintertime, students streaked from Bynum back to their dorms to wake themselves up for a full day of classes.
Photograph by Gary Simpson.

Studying in a Bell Tower alcove. Photograph by Lauren Parker.

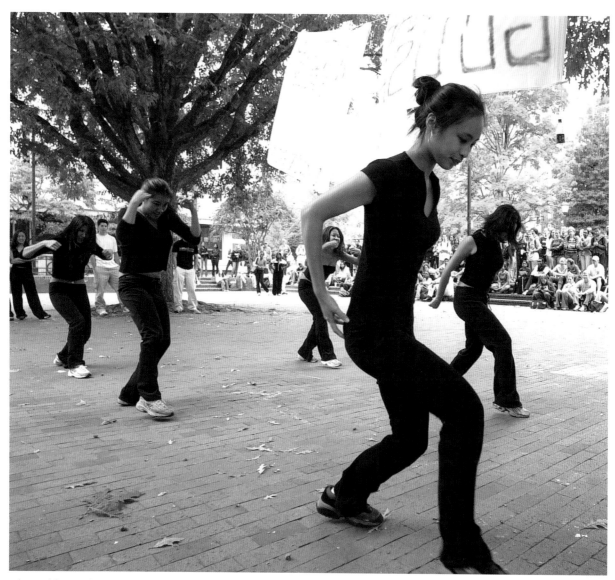

The gold-standard between-class activity: shakin' it.

Photograph by Dan Sears.

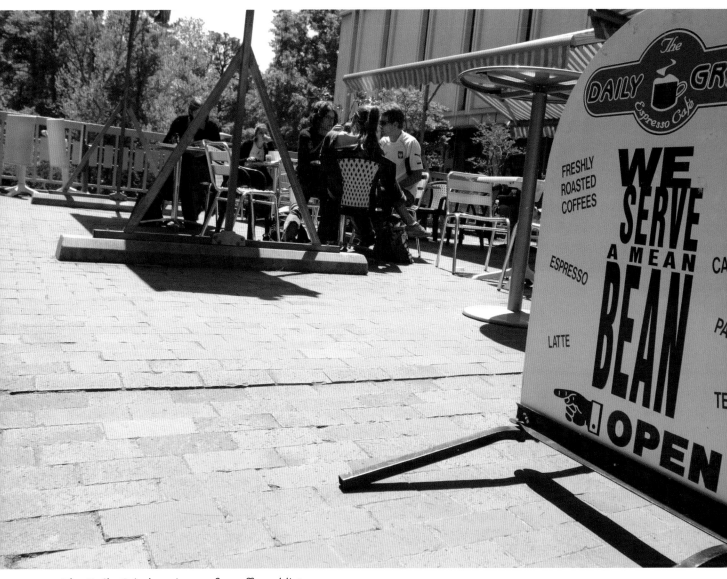

The Daily Grind—nirvana for coffee addicts.

Photograph by Andrew Synowiez.

The Walter Royal Davis Library, among the most intensively computerized and technologically advanced libraries in the world, houses more than 2.5 million volumes. Late each semester it also houses an abundance of cramming students. Photograph by Justin Smith.

College scene 101: student with reference book.

Photograph by Nancy Donaldson.

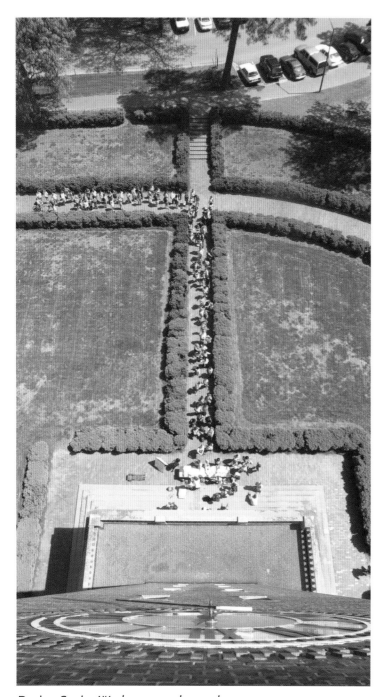

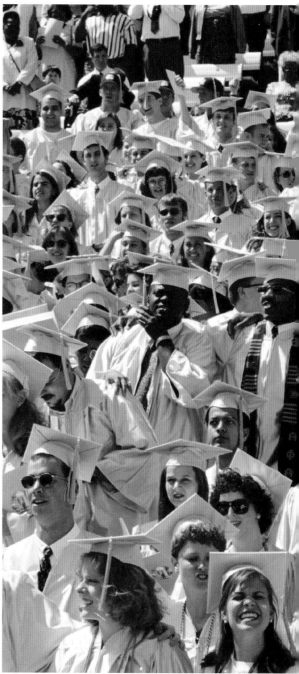

During Senior Week, soon-to-be-graduates line up to climb the Bell Tower just so they can say they did.

Photograph by Jessica Foster.

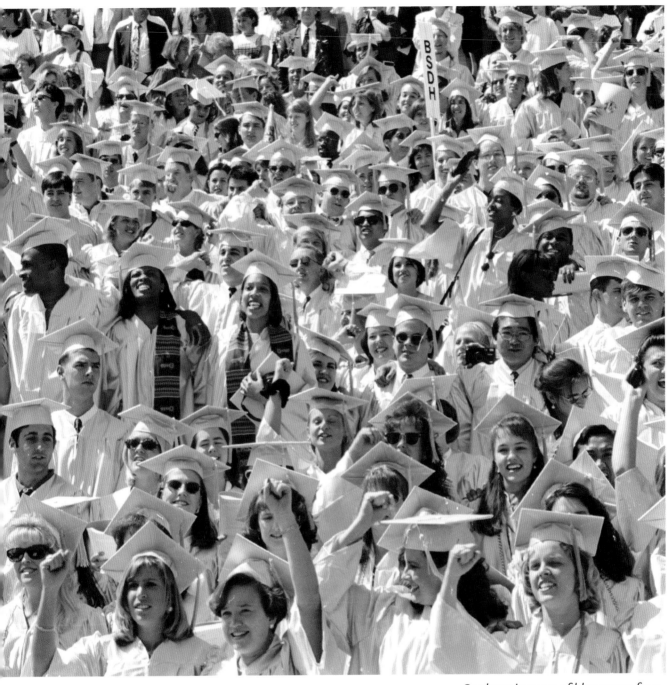

Students in a sea of blue pause for a moment of celebration before setting sail for their futures.
Photograph by Dan Sears.

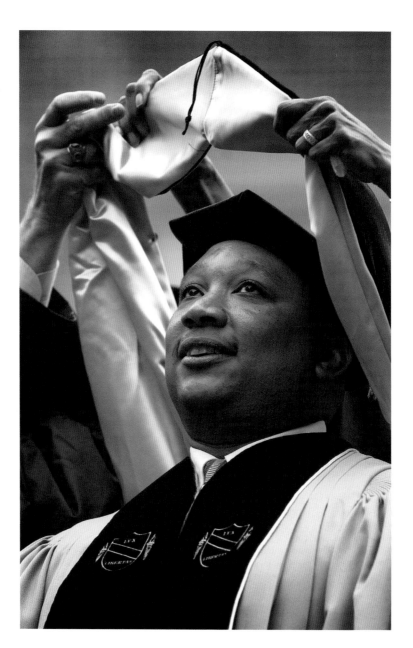

*Hooding ceremony
for new Ph.D.'s.*
Photograph by Dan Sears.

182

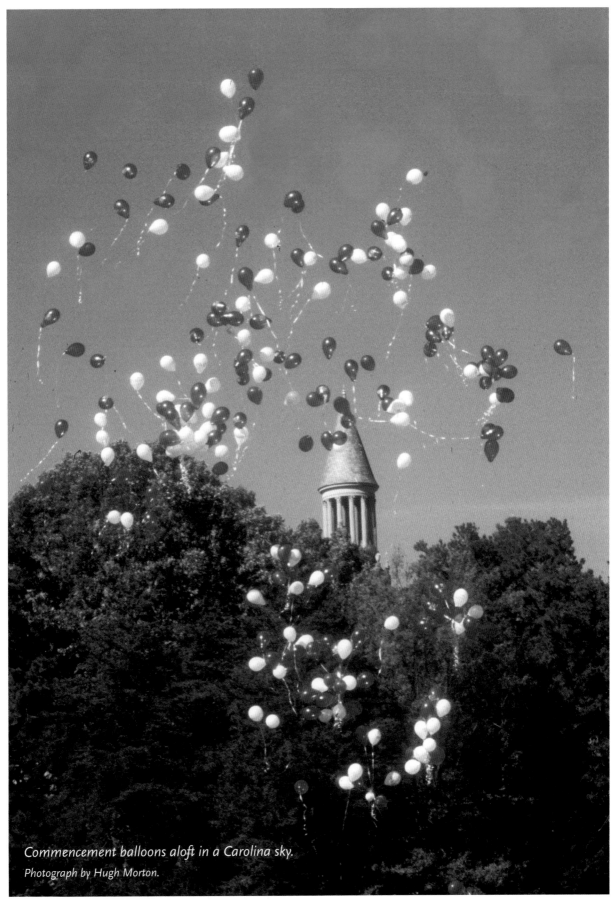

Commencement balloons aloft in a Carolina sky.
Photograph by Hugh Morton.

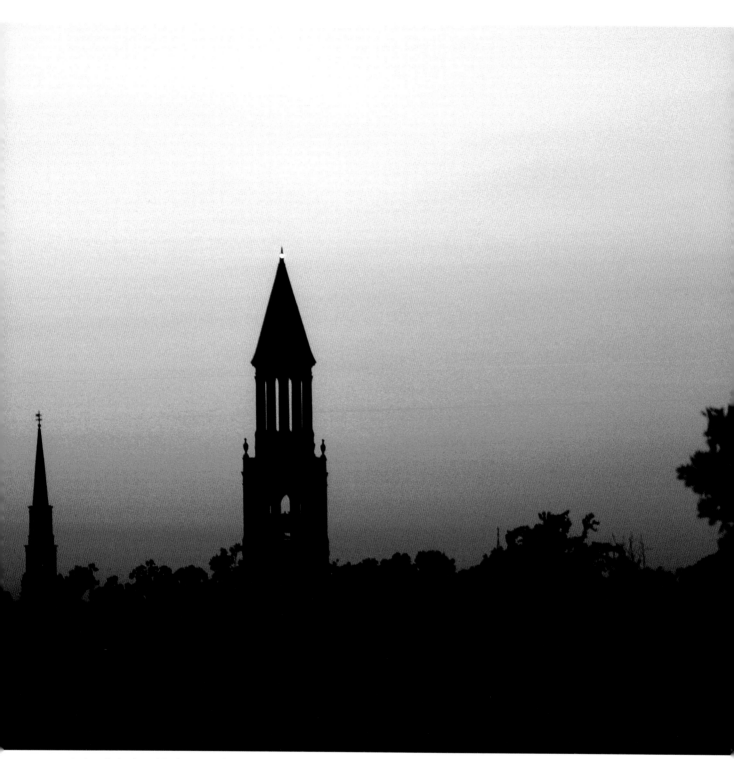

"*What is it that binds us to this place as to no other? It is not the well, or the bell, or the stone walls, or the crisp October nights, or the memory of the dogwoods blooming. No, our love for this place is based on the fact that it is, as it was meant to be, the university of the people.*" —*Charles Kuralt.*
Photographs by Justin Smith.

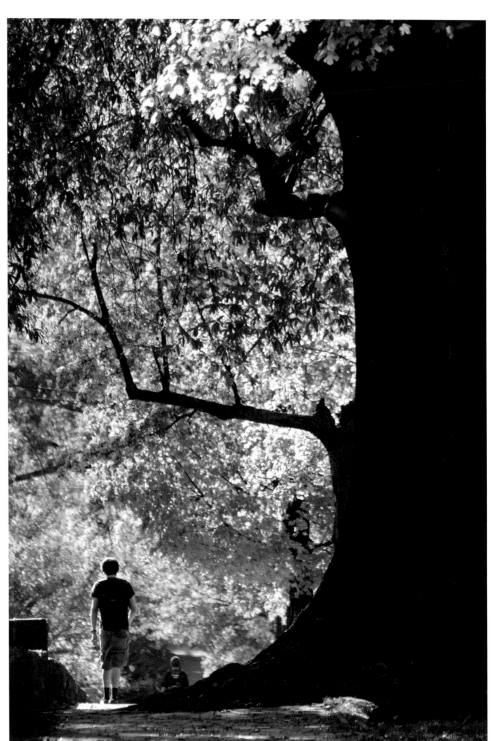